Castalia, Cold Creek, and the Blue Hole

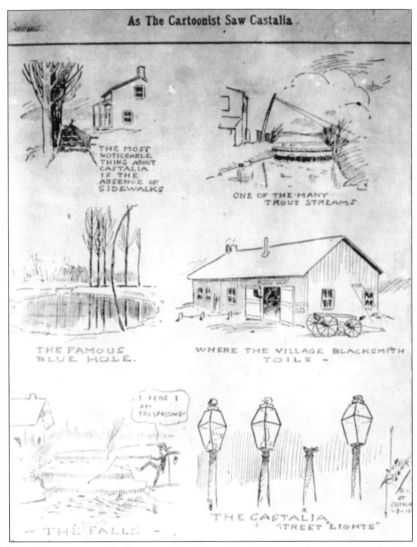

As The Cartoonist Saw Castalia

THE MOST NOTICEABLE THING ABOUT CASTALIA IS THE ABSENCE OF SIDEWALKS

ONE OF THE MANY TROUT STREAMS

THE FAMOUS BLUE HOLE.

WHERE THE VILLAGE BLACKSMITH TOILS -

I FEAR I AM TRESPASSING

- THE FALLS -

THE CASTALIA STREET LIGHTS

Ernst Niebergall, commercial photographer from Sandusky, produced this real-photo postcard of Castalia scenes, which appears to have been copied from a newspaper story. The cartoonist drew these images of the trout stream, the falls (at the Castalia Trout Club hatchery), and the famous Blue Hole. All of these subjects are thoroughly covered in this book. So now take a picturesque journey along Cold Creek from Castalia to Venice.

On the front cover: Between 1925 and 1990, it is estimated that several million curious visitors passed through this archway entrance to gaze into the famous Castalia Blue Hole. The arch-stone structure was created by Charles Eggert in 1935 using native tufa rock. The archway still stands today even though the Blue Hole was closed to the public in late 1990. (Author's collection.)

On the back cover: This Castalia Trout Club member is netting his trout out of the millpond just south of the railroad bridges. Cold Creek (locally called the Race) flows north past the clubhouse some seven miles to empty into Sandusky Bay at Venice. Cold Creek's fast-flowing, crystal clear water provides the finest trout fly-fishing stream in Ohio. Thousands of various sized trout offer fly-fishing challenges to the private club members. (Author's collection.)

POSTCARD HISTORY SERIES

Castalia, Cold Creek, and the Blue Hole

Glenn C. Kuebeler

ARCADIA
PUBLISHING

Published by Arcadia Publishing
Charleston SC, Chicago IL, Portsmouth NH, San Francisco CA

Printed in the United States of America

Library of Congress Catalog Card Number: 2007923201

For all general information contact Arcadia Publishing at:
Telephone 843-853-2070
Fax 843-853-0044
E-mail sales@arcadiapublishing.com
For customer service and orders:
Toll-Free 1-888-313-2665

Visit us on the Internet at www.arcadiapublishing.com

This early greeting postcard promotes the beautiful scenery in Castalia. The Blue Hole Park is certainly famous for its crystal clear spring reflecting the sky and the surrounding trees. Cold Creek flows through six-plus miles of beautiful natural landscapes, providing a perfect environment for the many trout anglers. Nearby underground caverns offer the visitors sparkling, crystal clear water pools and grottos for their enjoyment.

CONTENTS

ACKNOWLEDGMENTS

This book is dedicated to the Firelands Postcard Club, the Erie County Historical Society, and the many local area historians who have collected, preserved, and documented our rich history. These historians have labored over the past 100-plus years to capture the factual information both in writing and in pictures. Charles Frohman and Helen Hansen provided inspiration for this book.

Many Castalia- and Sandusky-area residents willingly shared their postcards, photographs, memorabilia, and historical information that significantly helped in the creation of this book. I especially want to thank the following major contributors: Robert Wolfbrandt, William Weichel, the Ellen Burgraff Quick collection, Wanda Stewart, Paulette Biglin, Sandy Conrad, Margaret Knerr, Mark Cloud, Carol Steuk, James Gallagher, Robert Lorenz, Gary Kihn, Alton Felske, David Berckmueller, Shirley and John Miller, Ronald Scheufler, Jeffrey Nielsen, Norma Eisenhauer, Melvin Myerholtz, Doug Lamb, Janeann Williams, Robert Lantz, and Richard Bell.

The following people provided much useful information, suggestions, and encouragement: Susan Lawyer, Mike Conrad, Kae Creech, Bruce Martin, Edward Mantey, James Winkel, James Norrocky, James Findley, Frank Harding, Barry Brunner, John Blakeman, Joe Braun, Cindi Brody, Elmer Grahl, Donald Guy Jr., Roger Gundlach, Robert Hess, Dan Longnecker, Linda Riggle, Dr. Joel Rudinger, Eric Schell, Dan Miller, James Matter, John Schaeffer, Janet Senne, Lou Schultz, Russ Brown, Eugene Dahs, Maggie Loroff, Donald Yontz, and Ernie Yetter.

All images with the photograph credit Hayes Presidential Center are courtesy of the Charles E. Frohman Photograph Collection, Rutherford B. Hayes Presidential Center, Fremont, Ohio. Special thanks to Nan Card for her excellent service in providing many of the vintage images by Ernst Niebergall.

Special thanks to Maggie Marconi of the Sandusky Library/Follett House Museum, and Laura Osterhout of the Buffalo and Erie County Historical Society for their research help and supplying images.

The research files of both the Sandusky Library and the Hayes Presidential Center were extremely helpful in providing historical information, especially the expansive personal files of Charles Frohman. I am very appreciative of the many organizations, business enterprises, and individuals that provided me with encouragement and letters of support for this project. I also want to thank my Arcadia editor, Melissa Basilone, for her professional guidance and timely help in creating this book.

I also thank my wife, Iris, for her help in organizing the postcards and editing the captions, and her tolerance of my research traveling and the clutter of books and files.

INTRODUCTION

Over the ages, trillions of gallons of crystal clear water have flowed through the subterranean aquifer system beneath Huron and Erie Counties in Ohio. Much of this water comes up to the surface through the natural springs (which the Wyandot Indians called the Cold Spring) in and around Castalia, at the current estimated rate of 10,000 gallons per minute (which equates to 14 million gallons per day and 5 billion gallons per year). This water flows northward as Cold Creek to empty into the Sandusky Bay at Venice and ultimately into Lake Erie. In the 1800s, this uninterrupted water flow powered gristmills, lumber mills, and paper mills. Pure water from the Crystal Rock Springs was piped east to Sandusky in 1893 for beer brewing and public consumption. The area around Cold Creek was also suitable for the growing of grapes for several local winemakers. Today the Cold Creek area provides for scenic sightseeing, private trout fishing, trout hatching, and entertainment sites.

Some 14,000 years ago, the Castalia area was covered by a glacier. The Bellevue-Castalia Karst Plain is a landform developed by the dissolving of the underlying limestone, dolomite, and gypsum. The features of this landform are characterized by sinkholes, caves, large springs, dry valleys, and sinking streams. Surface water draining into the solution-enlarged rock fractures generates the constant flowing groundwater aquifer system that supplies the area artesian springs.

Historians attribute the first recorded sighting of the Castalia-area springs to Maj. Robert Rogers and his Colonial Rangers during their travels through the area in January 1761. His account, quoted in James W. Taylor's *History of the State of Ohio* (1854) states "there is a remarkable fine spring at this place, rising out of the side of a small hill with such force that it boils above the ground in a column three feet high. I imagine it discharges ten hogsheads of water in a minute." A hogshead is defined as a barrel containing 63 to 140 gallons. It is reasoned that this spring was southwest of Castalia in the vicinity of the current Rockwell Springs. Cold Creek has its headwaters in the Castalia Upper Springs and in its natural state ran northward through flat prairie land forming hundreds of acres of quagmire marsh, also called the muskrat garden. The digging of artificial canals, the Race, in the early 1800s dried out the area, yielding rich farmland. Cold Creek has a fall of 57 feet over its seven-mile length from Castalia to Venice. Straight-line distance is four miles.

Erie County (created in 1838) and Huron County (created in 1809) comprised the Firelands, which were 500,000 acres of land granted to Connecticut property owners as compensation for their losses during the Revolutionary War fighting of 1779. The first settlers to Cold Creek were from New York in 1810. While there were confrontations with the local American Indians, more settlers came and began businesses on the Cold Creek shores. The first gristmill in the

Firelands was erected by Docartus Snow near the head of Cold Creek in 1810 with a capacity of 10 to 15 bushels of corn per day. Subsequent mills for grain, lumber, leather, and paper were constructed using the waterpower of Cold Creek water. The Race was dug around 1816 to direct the major flow of water from Castalia to Venice to power the mills. Russell Heywood arrived from Buffalo, New York, about 1831 and established two sizeable flour mills on the Race in Venice (1833) and on Homegardner Road (1841). As the rapidly flowing waters of Cold Creek never froze in the winter, vast quantities of flour were produced and shipped from Venice to many northeastern ports. Today the only remnants of these mills are the stone block walls of the Homegardner Road mill. The Venice mill foundation is now Margaritaville, a popular tavern and restaurant.

The famous Castalia Blue Hole was originally created around 1820 by the damming-up of the water for Snow's gristmill, which caused the vast sinkhole to form. Several more cave-ins and collapses, as late as 1914, left the Blue Hole at its current size of approximately 75 feet in diameter with a visible depth of 50 feet. Owned by the Castalia Trout Club, it was opened to the public, for a fee, in 1925. Millions of tourists came to admire this vast spring until it closed to the public in late 1990.

Trout were introduced experimentally into Cold Creek in 1868 by John Hoyt, owner of the Castalia Paper Mill. Trout eggs were brought from the east and successfully hatched in receptacles placed in the stream. The lower part of Cold Creek was leased in 1878 to the Castalia Sporting Club (later known as the Castalia Farms), which erected a clubhouse and hatchery. The Castalia Trout Club was organized in 1879 and bought the land, water rights, and the Blue Hole from the Castalia Milling Company. The fish hatchery at the junction of Homegardner and Heywood Roads is now owned and operated by the State of Ohio and is open to the public. The Race north of the Castalia Farms was later owned by J. Preston Levis and was known as the Millsite Farm. Sunnybrook Conference Center and Trout Club now owns the Race from the Heywood Road bridge to State Route 6 just west of Bardshar Road. The section of the Race just west of Sandusky Bay is now the Cold Creek Trout Camp. Rockwell Springs Trout Club was organized in 1900 and is located to the southwest of Castalia.

Other named blue holes exist around the world. A hard-water spring in Santa Rosa, New Mexico, is 92 feet deep and flows at the rate of 3,000 gallons per minute. It has been used by American Indians and white men alike and currently supplies 21 fish hatching ponds. Other blue holes are located in Wimberley, Texas; Key Largo, Florida; Egypt's Sinai Peninsula (a 203-foot dive site); and near Belize (a 400-foot-deep ocean dive-site on Lighthouse Reef Atoll).

The reader is now invited to view photographs and picture postcards of Cold Creek and the Castalia Blue Hole, from Seneca Caverns south of Bellevue, to Venice on the Sandusky Bay.

One

AREA GEOLOGY, CAVES, AND SPRINGS

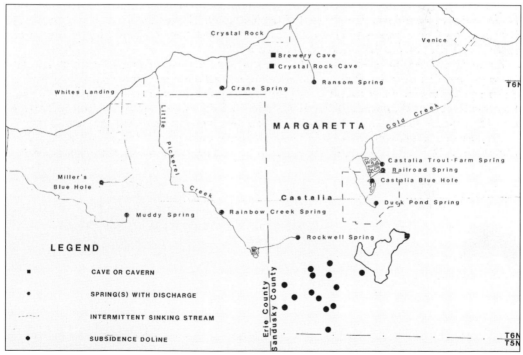

Gary Kihn's 1988 masters thesis provides this map of the various springs (Rockwell, Castalia Blue Hole, and Crystal Rock) that are presumed to be fed from the same underground fractured-rock aquifer or river as is Seneca Caverns, located south of Bellevue. Several attempts have been made to trace the water flow with dyes from Seneca Caverns to the Blue Hole, without conclusive results.

This expanded version of Margaretta Township from the 1896 Erie County atlas shows the original course of Cold Creek flowing northwest from the Castalia Springs to the Castalia Sporting Club and the old channel flowing northeast. The map also shows the Race channels that were dug to direct water to the Cold Creek Trout Club fishing streams and the Heywood flour mills farther north at Venice.

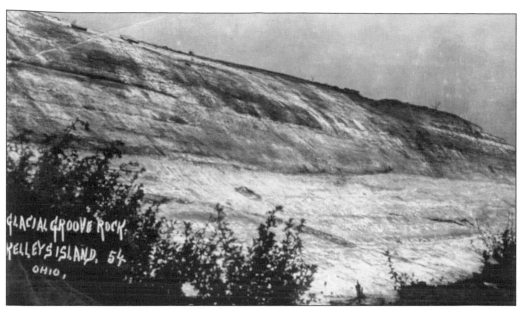

About 300,000 years ago, the Illinoisan-age glacier covered over 70 percent of Ohio's landscape. Several thousand feet thick, it took over 5,000 years to completely disappear from Ohio. The receding glacier left deep gouges and grooves in the bedrock. Some 14,000 years ago, the last continental ice sheet retreated northward with meltwater creating ancient Lake Maumee, whose water levels were about 230 feet higher than modern Lake Erie. The receding Wisconsin glacier deposited mixtures, called moraine, of clay, silt, sand, gravel, and boulders, in thicknesses up to 80 feet. Castalia lies on the flat Lake Plain, at the edge of the great marl-peat marsh known as the Castalia Prairie. The Bellevue-Castalia Karst Plain is underlain by up to 175 feet of limestone, dolomite, and gypsum and encompasses many sinkholes, caves, and caverns. Surface water drainage into underground rock fractures creates the flowing aquifer system that feeds the many artesian springs covered in this book.

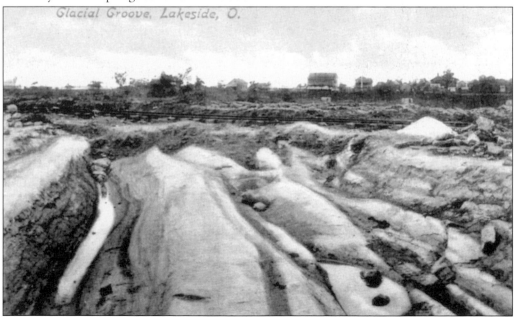

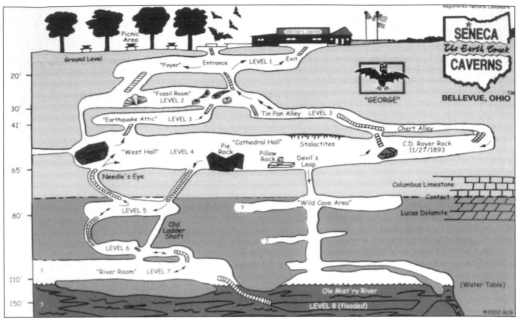

Seneca Caverns are located near Flat Rock, four miles south of Bellevue, and consists of seven underground levels extending down over 110 feet. Level eight is flooded with crystal clear flowing water called Ole Mist'ry River, which is part of the vast groundwater aquifer system that flows constantly beneath the surrounding region. This same flowing aquifer discharges into the Blue Hole and other springs farther north and finally into Sandusky Bay.

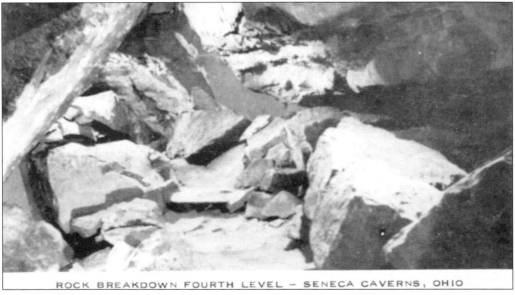

ROCK BREAKDOWN FOURTH LEVEL – SENECA CAVERNS, OHIO

Recorded history indicates Seneca Caverns was discovered in 1872 by two boys hunting near Flat Rock. Their dog disappeared down a sinkhole, which opened into two caves. However, the caves may have been known to area residents as early as 1820. Commercialization of the caverns was attempted in the early 1890s. Supposedly, visitors traveled via the Mad River Railroad to explore this new underground mystery cave system. This postcard shows some rock breakdown in level four.

Old Mystery River flows in the flooded eighth level, up to 165 feet below the surface. The caverns were opened to the public in 1933 by the Don Bell family and typically receive over 35,000 visitors yearly. Over thousands of years, the dissolving of gypsum between gaps in the rocks has caused the overlying rocks to collapse. Depth of the clear water flowing in this beautiful river or aquifer is unknown.

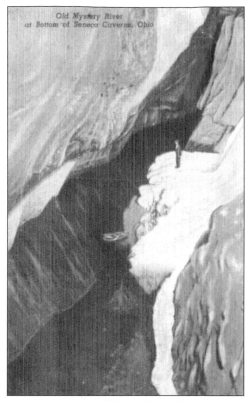

Old Mystery River at Bottom of Seneca Caverns, Ohio

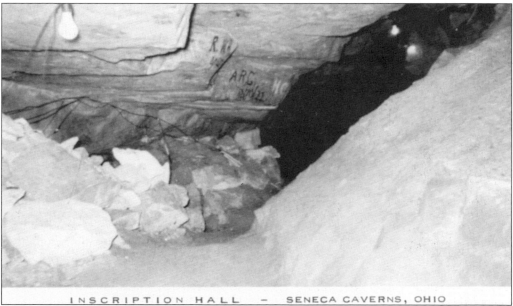

INSCRIPTION HALL — SENECA CAVERNS, OHIO

Inscription Hall lies about 70 feet underground and is filled with chiseled and painted inscriptions dating back to 1872. Most are the names and visitation dates inscribed by early-day area spelunkers and can be found throughout the caverns. Electric lights were installed in 1932 and were powered by a portable power plant with wet cell storage batteries. Full electrical service came to the area in 1937.

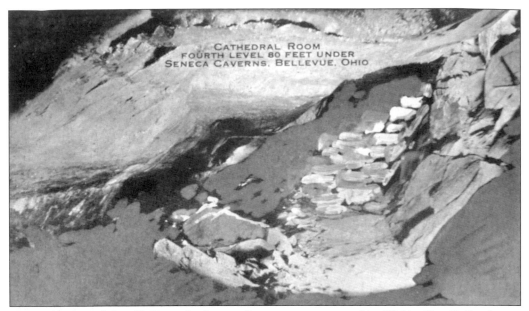

CATHEDRAL ROOM
FOURTH LEVEL 80 FEET UNDER
SENECA CAVERNS, BELLEVUE, OHIO

Originally named Good's Cave, the Seneca Caverns were renamed in 1936 by Don Bell to honor the native Seneca Indians. Richard and Denise Bell currently own and operate the caverns, which are one of Ohio's largest underground geological wonders. The largest room is 250 feet in length, and the caverns remain at a constant temperature of 54 degrees Fahrenheit. Over one million visitors have explored the caverns since their opening in 1933.

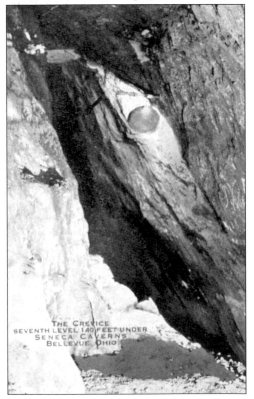

THE CREVICE
SEVENTH LEVEL 140 FEET UNDER
SENECA CAVERNS
BELLEVUE, OHIO

The underground aquifer is continually recharged by surface rainwater percolating down through the ground via sinkholes and vertical fractures in the limestone. Major fluctuations in the lower cavern water level do occur, particularly when major surface flooding occurs. The July 1969 rainfall of nine inches in four hours caused the water level to rise 130 feet to the cavern entrance. It took almost four months to drop to the preflood level.

Maj. Robert Rogers (1731–1795) and his Colonial Rangers are said to have been the first to notice the springs that feed Cold Creek. They came through the Castalia region in January 1761, and Rogers recorded in his journal seeing a remarkable spring boiling out of the side of a hill in a column three feet high. Historian Charles Frohman concluded this spring was most likely in the vicinity of the current Rockwell Springs Trout Club southwest of Castalia.

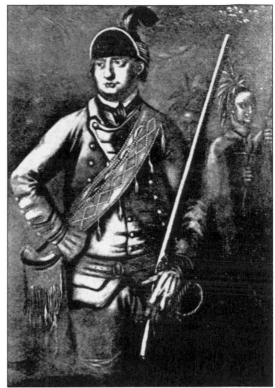

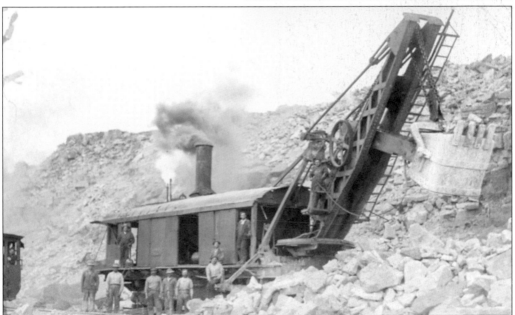

The springs feeding the Rockwell Springs Trout Club streams are located just north of State Route 101, southwest of Castalia. Opposite is a small hill behind which is the former Wagner Quarry, as depicted in this real-photo postcard published by E. H. Schlessman, a commercial photographer from Sandusky. Perhaps this is the hill that Major Rogers viewed in his 1761 journey to Sandusky Bay. If so, no such flowing spring exists on this hill today.

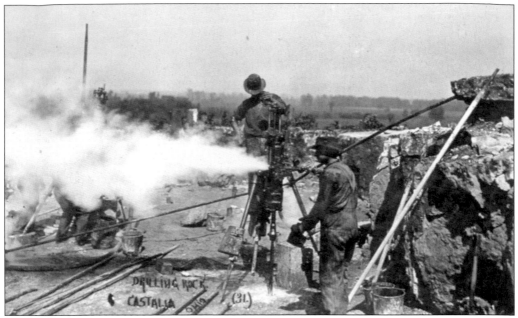

This 1909 postmarked postcard shows the rock drilling in the Castalia Quarry No. 5 south of Route 101. Limestone was quarried from 1870 to 1929, mainly for shoreline rip-rap and general building purposes. These men worked for as little as 17¢ an hour. The quarry also operated from 1954 to 1965. In 1987, the 152 acres of quarry land became Erie MetroParks Quarry Reserve. The 70-foot-high rim of the quarry is at an elevation of 782 feet.

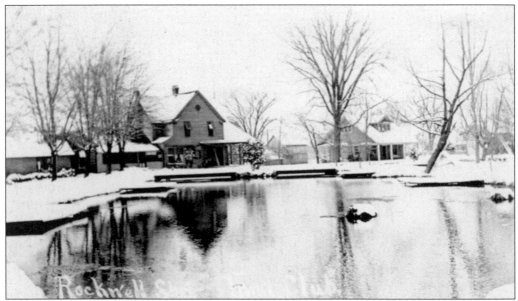

Rockwell Springs Trout Club is located two miles southwest of Castalia on Little Pickerel Creek. In 1839, Major McIntyre and James Green Sr. built a millrace, gristmill, and blacksmith shop approximately one-half mile north of the natural sink that was first named Rockwell Springs in an 1842 lawsuit. It is presumed these springs are fed by the same flowing aquifer as is the Blue Hole. This real-photo postcard by W. M. Hire is postmarked 1914.

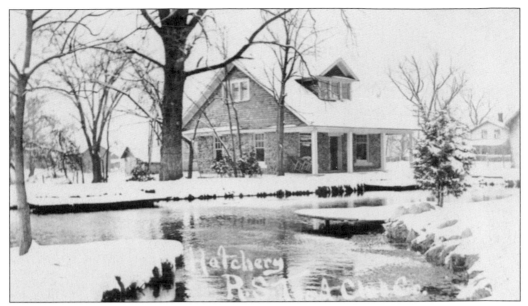

In 1840, a sawmill was powered by the Rockwell Springs water. An 11-foot-high dam at the mouth of a one-half-mile millrace provided the necessary head of water. In 1868, the mill was owned by Berlin Boice, who operated it until 1885. The Boice Water Mill was one of the old landmarks of this vicinity. Boice then leased the property of the upper stream to several men for fishing. The mill building and machinery were removed by 1901.

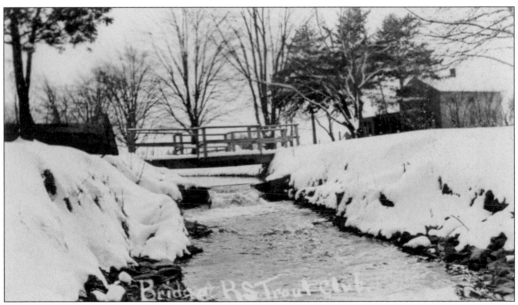

The first trout fishing club at this site was incorporated in 1893 as the Bellevue Trout Club. Membership cost $150 and was limited to 35 members. Fly-fishing only was permitted. In April 1900, the name was changed to the Rockwell Springs Trout Club. Only speckled trout were stocked in the stream, and a small fish hatchery was maintained in the basement of the recreation building at the club.

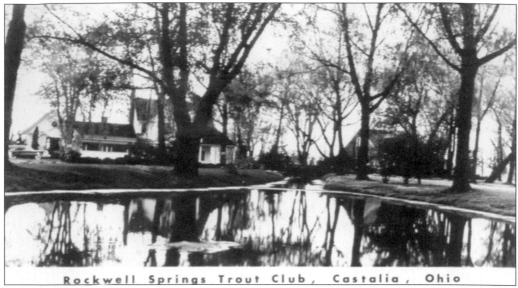

Rockwell Springs Trout Club, Castalia, Ohio

The next three real-photo postcards are from the 1950s. A clubhouse was erected in the early 1900s. Members used metal plates pulled by mules to dig the original streambed and snakelike channels to maximize the fishing habitat. Families came from the major Ohio cities by train and were then conveyed to the club by horse and buggy. The men fished, and the women and children pursued various amusement activities.

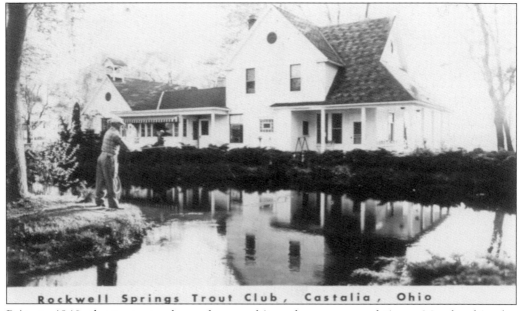

Rockwell Springs Trout Club, Castalia, Ohio

Prior to 1940, the property changed ownership and names several times. Membership also declined for various reasons. In December 1940, the defunct club was purchased by George Ball (Ball mason jar family) and C. Webb Sadler (former Sandusky city manager). Under the astute management of Sadler, the club grew to over 1,000 members from over 20 states, including many influential businessmen. Celebrities often came to Rockwell Springs to enjoy this fly-fishing paradise.

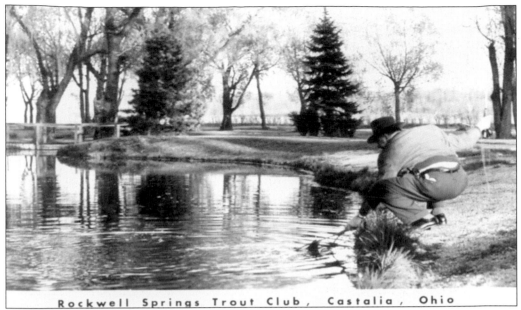

Rockwell Springs Trout Club, Castalia, Ohio

Today Rockwell Springs is one of the finest clubs of its kind in the United States. More than 20,000 brook, brown, and rainbow trout inhabit the two and a half miles of crystal clear stream that winds around the 125-acre oasis of landscaped beauty. Over 600 members come to enjoy the fishing and social amenities. The eight 60-foot deep artesian wells discharge over 3,000 gallons of water per minute, exiting via Little Pickerel Creek to Sandusky Bay.

Maybe that is "Was it" — Celia

Green Springs is about 11 miles west of Bellevue, and its sulfur water springs have been a health resort location since the 1800s. The famous Oak Ridge Hotel, pictured on this 1906 postcard, sold the water for its health-enhancing virtues. The pond is generated by eight million gallons of 50-degree sulfur water gushing up daily through a fissure in the bedrock. This naturally occurring spring may well be connected to the aquifer system feeding the Castalia Springs.

19

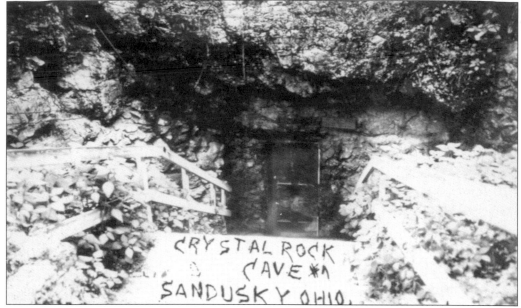

Crystal Rock Caves are located seven miles west of Sandusky. The four caverns reported in 1887 were part of a 30-acre picturesque country park owned by C. N. Martin and were located in a hill 60 to 100 feet above the surface of Sandusky Bay. This northwest area of Margaretta Township was then known as Mustcash. Cave No. 1 contains many stalactites, stalagmites, and other unusual rock formations.

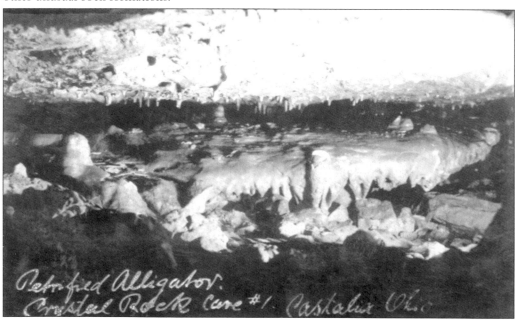

Historian Hewson Peeke in 1916 notes the name Mustcash as being of American Indian derivation, meaning they wanted money not produce for their animal skins, insisting on "must cash." Early exploration indicated a long narrow cavern with only a four- to six-foot-high ceiling. Crystal clear water was found in the lowest levels, as deep as 100 feet. Skin divers have explored the water depths in Cave No. 2 on numerous occasions.

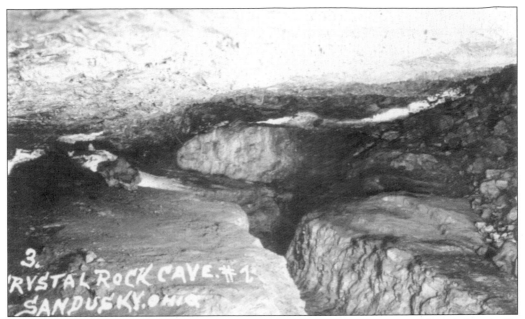

Fred Hess, from southern Ohio, first developed Cave No. 1 into a safely accessible and electrically lighted visitor attraction in 1930. Hess opened up the cavern by hauling out tons of limestone rock that he dug out by hand. Stairs were built leading down to an expanded entrance opening. It was reported in 1933 that thousands of visitors were paying 10¢ admission to explore the mysterious caverns and marvel at the silent flowing Lost River.

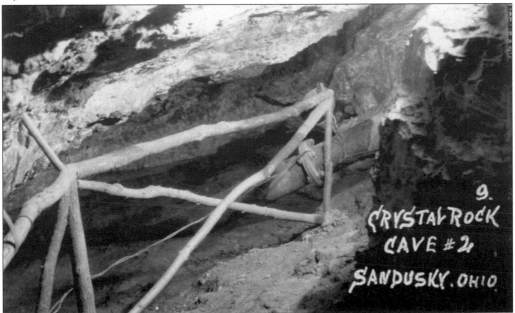

Cave No. 2 is also called the Brewery Cave as it supplied clear water to the Stang Brewery in Sandusky from 1893 to 1904. This postcard, on the right side, shows the six-inch diameter cast iron pipe that conveyed the water seven miles to the east. This water is presumed to flow from the same aquifer system discharging into the Blue Hole to the southeast. In 2006, James and Dian Winkel built their new house above Cave No. 2.

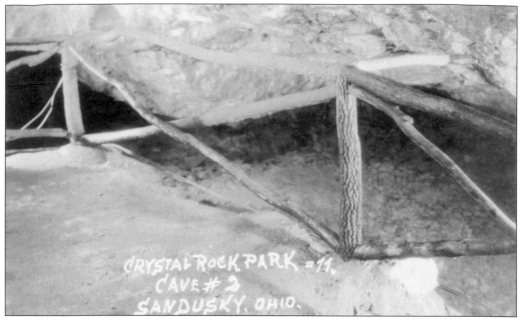

In 1896, it was claimed by experts that this "pure" water was unequalled by any other for brewing purposes. Water was also sold in Sandusky by the Crystal Rock Water Company. However, in 1904, water service was discontinued after discovering that water quality was not uniform. The pipeline was taken up in 1907. In 1893, the City of Sandusky even considered using Crystal Rock water because of its purity over that of Sandusky Bay.

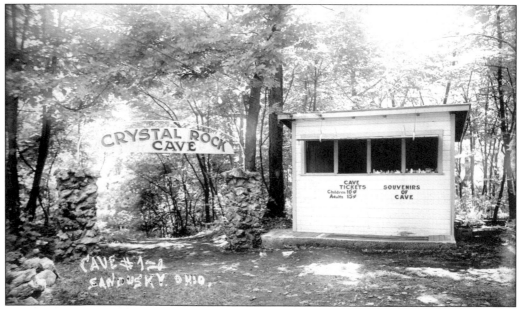

This late-1930s photograph shows the entrance archway to Crystal Rock Cave No. 1 and the small ticket-souvenir building. Adult tickets by then cost 15¢. These structures no longer exist. In later years, Crystal Rock Park developed into a popular recreation site with a big dance hall, which subsequently became a roller-skating rink. The rink was destroyed by fire in 1964. (Hayes Presidential Center.)

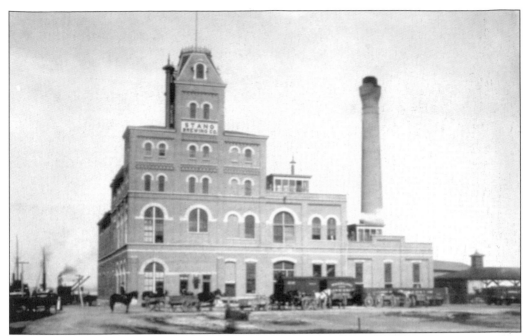

Starting with the usage of Crystal Rock water in 1893, Crystal Rock became the Stang Brewery's trademark brand of beer. Frank Stang's original brewery was destroyed by fire in 1891. The rebuilt Stang Brewery shown in this photograph was located on Madison Street between Broadway and King Streets in West Sandusky and reopened in 1893. Jacob Kuebeler's Brewery on West Tiffin Avenue began in 1867, burned down in 1892, and also reopened a new building in 1893.

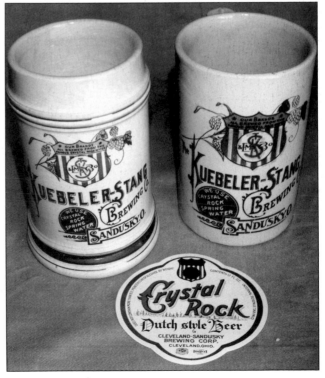

The two breweries merged in 1896 as the Kuebeler-Stang Brewing Company. The Crystal Rock brand name continued to be used, as shown on these two beer mugs. Note the top of the logo shield on the mugs says "Our Brands All Brewed From the Famous Crystal Rock Water." The use of Crystal Rock Spring Water was highly advertised in the brewery's display signs and in their newspaper advertisements.

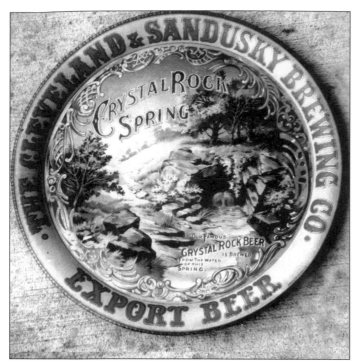

This pre-Prohibition Crystal Rock beer tray from the early 1900s displays an attractive wooded spring scene. The lettering notes "Our Famous Crystal Rock Beer is Brewed From the Water of this Spring." In 1898, Kuebeler-Stang Brewery merged with seven other Cleveland breweries to become the Cleveland and Sandusky Brewing Corporation (CSBC). Crystal Rock brand beer was continued after Prohibition ended in 1933 up until the last operating plant in Cleveland closed in 1962.

This colorful, 18-inch diameter, reverse-painted-on-glass sign is a rare piece of advertising for Crystal Rock beer. The logo shield has the same wording as on the mugs in the previous photograph. Vintage saloon photographs show these fragile signs hanging outside on the doorway frames. An early CSBC brochure extols the healthful virtues of Crystal Rock water as being "a remarkable aid to the digestion and assimilation of food."

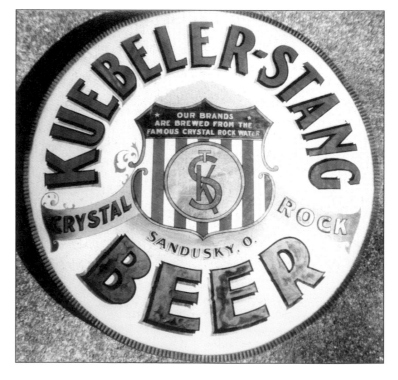

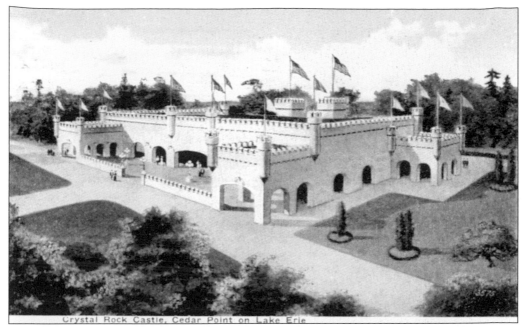

Crystal Rock Castle, Cedar Point on Lake Erie

The Crystal Rock Castle was built in 1904 at the famous Cedar Point, Queen of the American Watering Places, resort on Lake Erie. This medieval European palace-style building was built by the Kuebeler-Stang Breweries in Sandusky as a retreat for lovers of Bohemian life. Park visitors walking from the boat landing pier were enticed into the strategically located and popular beer garden. Crystal Rock beer was sold here until Prohibition was enacted in July 1919.

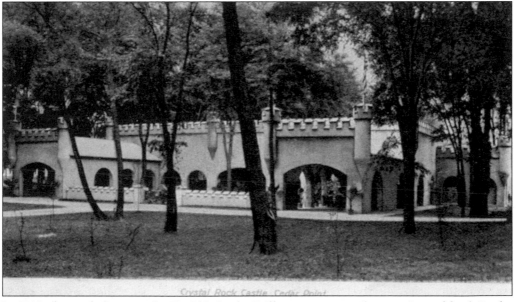

Crystal Rock Castle, Cedar Point

In 1919, the castle became the Ye Old Castle Grill restaurant, serving a variety of food. In the 1940s, it also housed the resort's fire department and first aid station. The Ford Model T fire truck shared the building with Fred Posner's and later Irving Ross's lunchroom. In the late 1950s, it was the resort maintenance shops. It was burned down in the early 1960s to make room for new attractions.

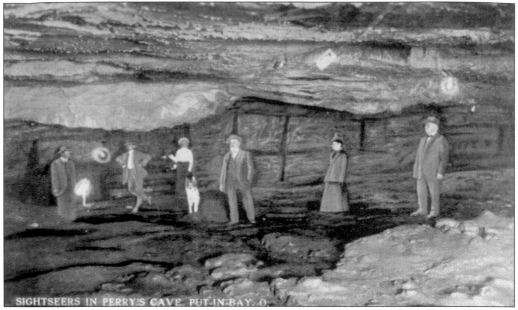

SIGHTSEERS IN PERRY'S CAVE, PUT-IN-BAY, O.

South Bass Island (Put-in-Bay) in Lake Erie has over 20 caves, most of which are undeveloped. Native American artifacts and skeletons have been found by the island's settlers since the early 1800s. Most of the caves are dolomite-layered collapsed-dome type resulting from seeping rainwater dissolution of the gypsum layers. Perry's Cave supplied drinking water to Commo. Oliver Perry's crews during the 1813 battle of Lake Erie. It was opened to the public in 1870.

Ernst Niebergall (1876–1954) was an early Sandusky commercial photographer who took a lot of area photographs that he published as real-photo postcards. Many of these are included in this book. Born in Germany, he came to Sandusky about 1908 where he engaged in exacting black-and-white photography using 14 cameras plus a panoramic camera. During World War I, he was treated as an enemy alien and his cameras were impounded for the duration of the conflict. (Hayes Presidential Center.)

Two

Cold Creek
and Castalia

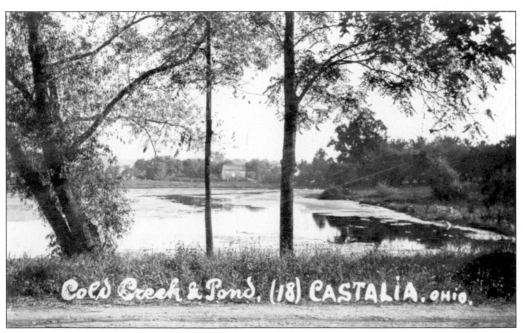

This early postcard scene looks south across the Cold Creek pond, also called the Upper Springs. American Indians camped in this area until the pioneer settlers began arriving in the early 1800s. Docartus P. Snow, from New York State, arrived in the spring of 1810 and established a gristmill on Cold Creek. These were known to the American Indians as Cold Spring, which accounts for the outlet of 48 degree water being called Cold Creek.

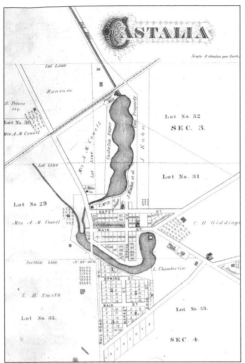

Cold Creek headwaters arise from three natural springs in the large duck pond in Castalia. Water flows west under two bridges on State Route 269 and then immediately northeast into the Castalia Trout Club property. Route 269, now named Washington Street, was previously named Railroad Avenue, then Norwalk Street, and Mustcash Road. The 1836 plat map of Castalia notes, "Cold Creek Never Failing Water in Abundance." This map is from the 1874 Erie County atlas.

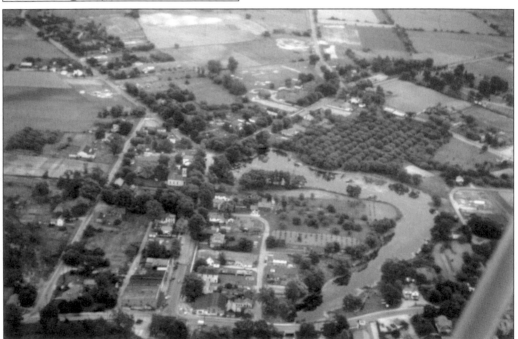

This 1947 aerial photograph of Castalia Village (taken by Hazel Downing and Fritz Loroff) shows the Cold Creek pond with the widest portion in the center of the view. Two of the outlet conduits are in this northwest pond location near Main Street. The third outlet is centrally located. On a sunny day, one can observe the water flowing from these shallow springs. The outlet under Route 269 can be seen in the lower right. (Janeann Williams Collection.)

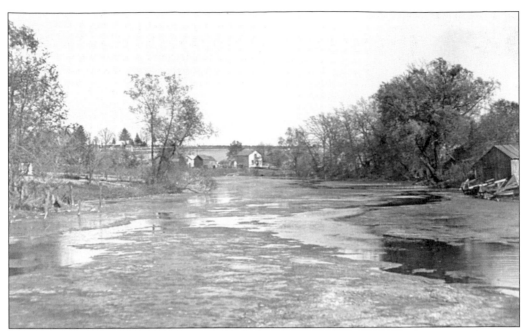

This early-1900s view of the pond shows the Castalia cemetery in the left middle portion. More buildings can now be seen south of the pond. The discharge rate was measured at 6,000 to 7,000 gallons per minute by Gary Kihn in 1988. Prior to the formation of the Blue Hole spring, all of the Cold Creek water flowed aboveground north to the Sandusky Bay. The 1831 Margaretta Township map shows four branches of Cold Creek.

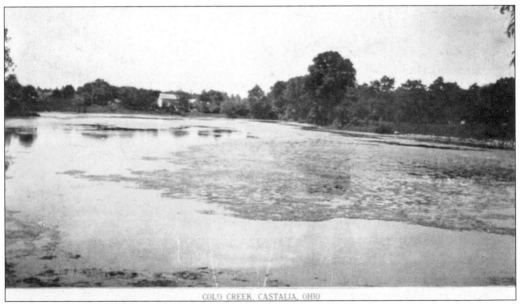

COLD CREEK, CASTALIA, OHIO

This 1910 postmarked card shows a wider view of the Cold Creek pond looking south. Note the heavy algae and scum vegetation floating on the surface. Homes have yet to appear on the west bank (to the right side). The straight line to the bay is about three miles. Before the millrace channels were dug north to Venice, the natural water channels converted several hundred acres of flat prairie land into a quagmire marsh and muskrat garden.

This Ernst Niebergall photograph shows numerous buildings around the pond. Early farmers were C. H. Giddings, L. Chamberlin, and J. Nolan. The 50-plus-acre Giddings farm and orchard illustrated in the 1874 atlas is listed for sale at $100 per acre. Calvin Caswell's farm, just to the east of Giddings, encompassed 600 acres of rich farmland and fruit orchards. Caswell was the largest wheat grower in Erie County, hauling his grain to the Castalia and Heywood flour mills. (Hayes Presidential Center.)

This view is looking northwest from the cemetery to the distant smokestacks of the Castalia Cement Mill. The Congregational church, dedicated in 1848, can be seen at the far right just above the pond. Cold Creek can be seen flowing west in the center of the picture. The winter of 1831–1832 was the coldest known in northern Ohio, freezing all the mill streams except Cold Creek. Northern Ohio and southern Michigan were entirely dependant on Cold Creek mills for grinding.

This 1912 postmarked Niebergall card view looks north along Bellevue Street (now Route 269 and South Washington Street) into Castalia. The road jogs left over Cold Creek. Early historians referred to Cold Creek as "one of the most permanent water powers in the state."

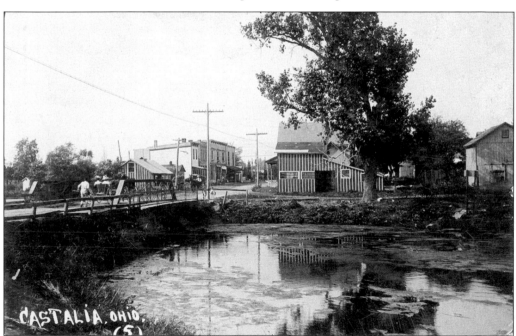

Bellevue (or Washington) Street crosses the iron truss bridge over Cold Creek. The large building on the left was home to numerous businesses, including the Blue Hole Restaurant. This may have been the site of Docartus Snow's gristmill. Cold Creek flows around this building and then northeast again under Washington Street. It is presumed that the covered bridge (see page 32) was replaced by the truss bridge.

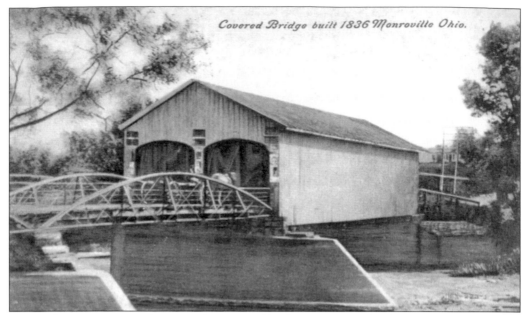

Castalia historians report that a wooden covered bridge once crossed Cold Creek at this location. While no actual illustrations or photographs of the covered bridge in place have yet to be found, it may have looked similar to the Monroeville covered bridge on this 1915 postcard. An early-1900s photograph of Milan also shows a long, double-wide covered bridge spanning the Huron River.

This 2006 photograph shows a 55-foot-long section of the Castalia covered bridge that was moved in the late 1800s to a farm near the Townsend School. It was towed on skids about five miles by horses over frozen ground. This structure was used as a barn and was 20 feet wide and about 21 feet high to the peak. It has since collapsed. Supposedly a shorter section of the Castalia bridge was moved elsewhere but was destroyed years ago.

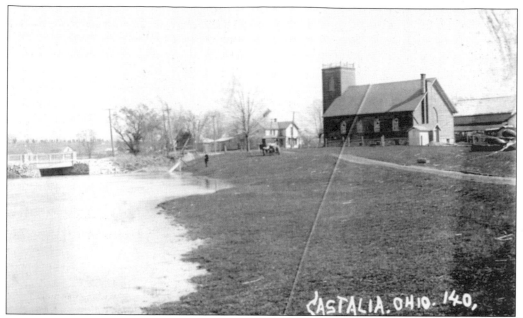

This 1926 postmarked postcard view shows the Lutheran church just to the southwest of Cold Creek as it flows from the pond under Route 269. The iron truss bridge has since been replaced. The bank of Cold Creek has now been smoothed and more steeply banked. The cemetery is visible in the left background.

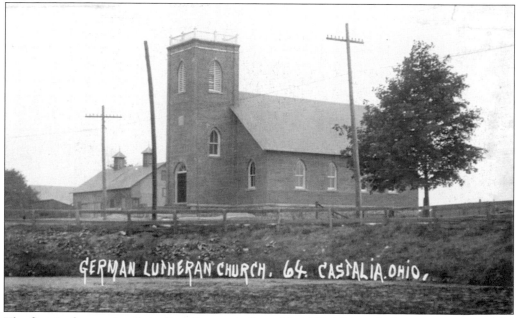

The first Lutheran church in Castalia was dedicated in 1871. This real-photo postcard is of the new church completed in August 1911, near Cold Creek, at a cost of $5,000. This location was previously occupied by the Smith Creamery and later by a livery stable operated by Jerome Hoofner. A parsonage was purchased in 1919, and educational wings were added in 1955 and 1967.

This photograph shows Cold Creek flowing under the bridge for the Lake Shore Electric (LSE) streetcar crossing above it; the streetcar is stopped at the crossing for Washington Street just north of Main Street. The cement mill is visible in the upper left. The other branch of Cold Creek is visible headed northwest. Just north of this intersection with Depot Street, Cold Creek flows northeast under another bridge on Route 269 into the Castalia Trout Club property.

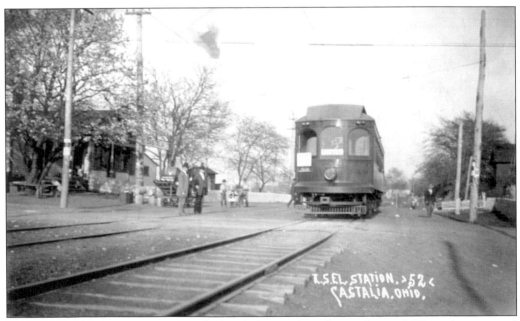

This LSE streetcar is entering Castalia headed west along Depot Street. LSE service operated through Castalia to Clyde and Fremont from 1907 to 1938 when the company went out of business. LSE also had a spur line into the Wagner Quarry on Route 101 to haul fill stone for its roadbeds.

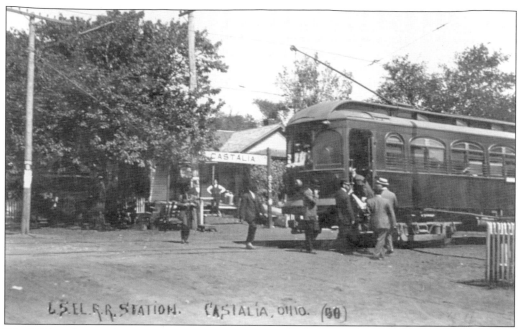

The LSE station on Depot Street in Castalia was just to the east of Route 269 (North Washington Street). This streetcar is taking on passengers for its trip west to Clyde.

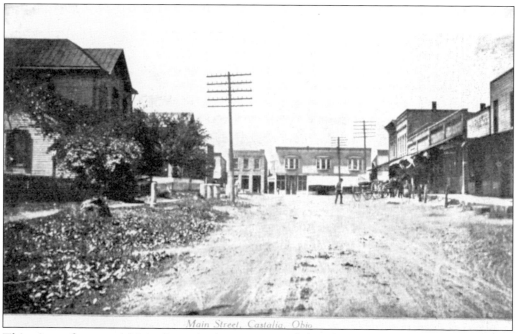

This view of unpaved Main Street looks west toward the Blue Hole restaurant built in 1900 by Jay Smith. The building on the left is the original Castalia Banking Company, chartered in 1905 as a state bank with capitalization of $25,000. The bank moved across Main Street in 1946. The row of buildings on the right housed numerous stores and saloons, which were destroyed by fire in 1874. The rebuilt buildings are still in use today.

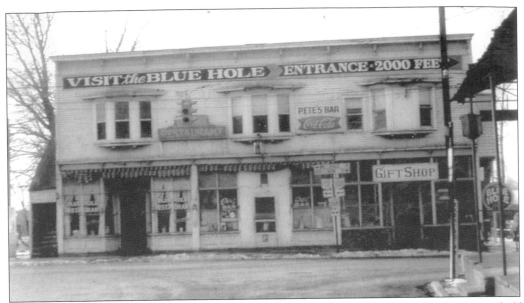

This photograph advertises visiting the Blue Hole located to the right (north) about one-half mile. Note the large, round Blue Hole sign at the right side. The far-left doorway is to the Blue Hole Restaurant being operated by the Claude Peter's family in 1964 when the building was torn down. The center doorway is to Pete's Bar, which was selling Crystal Rock beer, among other brands. Over time, the second floor had a pool hall, a theater, and apartments.

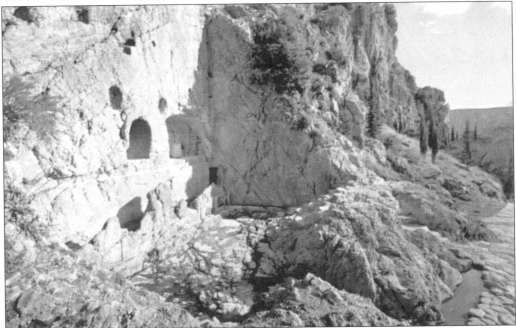

Castalia was platted in 1836 by Marshall Burton and recorded in the Huron County courthouse. The 1836 village map shows both the upper and lower Cold Creek ponds. Ebenezer Jessup named the village after the Grecian Kastalia Fountain located near the ancient sanctuary of the Oracle of Delphi in the temple of Apollo. This spring, in the awesome gorge of Phleboukos, dates from early Roman times (5th century BC). The author visited Greece and this spring in April 2006.

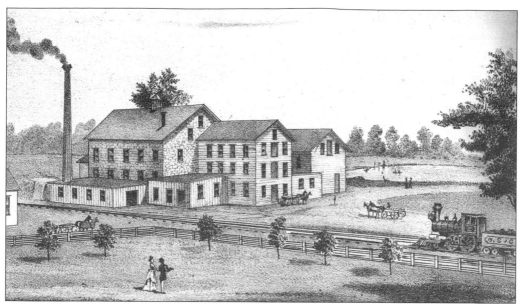

Mills were built on Cold Creek to utilize the waterpower. In 1810, Docartus Snow established a corn gristmill west of Main Street. Other mills included Mack's sawmill (1822), Joshua Pettingill's gristmill (1819), and Charles Butler's hide tanning mill (1813). The 1874 atlas illustrates the Castalia Paper Mills operated by John Hoyt starting in 1864. This mill became a flour mill for the Lilly brand name. It was destroyed by fire in 1874 and torn down in 1890.

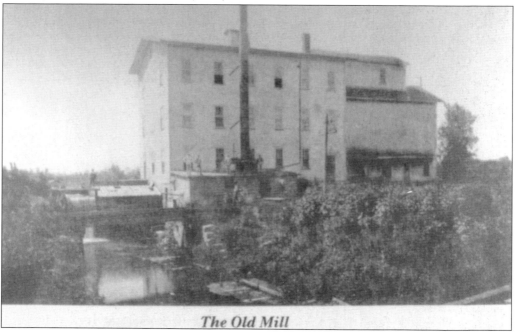

The Old Mill

In 1875, the Castalia Milling Company built a four-story flour mill for $8,000 at the intersection of Cold Creek and the railroad. The capacity was 125 barrels per day using a 12-foot waterwheel plus an elevator to store 20,000 bushels of wheat. In 1889, the mill was moved to the west about 500 yards and power changed to steam. In 1913, the mill elevator belonged to John Parker. Snow's dam was still present in 1905.

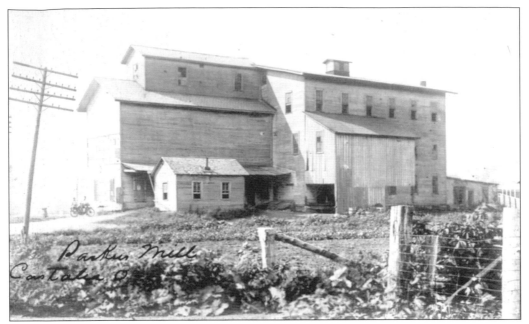

The Castalia Mill, on North Washington Street next to the Blue Hole entrance, was operated by the Gallagher Brothers in 1903. In 1919, it became a co-op. Here the farmers could sell their grain crops and purchase fertilizer, animal feeds, and coal. Grain was stored for later shipment on the nearby railroad lines. The Castalia Elevator and Supply Association ceased operations in 1988, and the buildings were demolished in 1989.

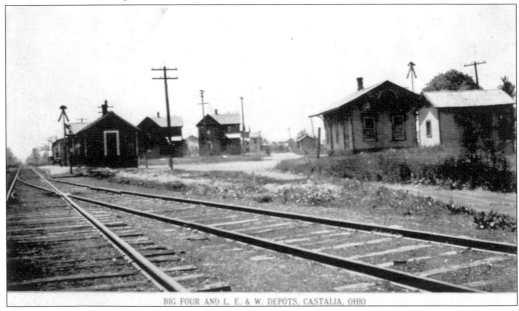

BIG FOUR AND L. E. & W. DEPOTS, CASTALIA, OHIO

Two parallel railroads running just north of Castalia and servicing the elevator and the cement mill were the Big Four and the Lake Erie and Western (LE&W). These two rail lines crossed Cold Creek just north of the Blue Hole. In 1896, the Big Four was the Cleveland, Cincinnati, Chicago and St. Louis Railroad. The LE&W became the Nickel Plate Railroad. The Nickel Plate depot building (on the right) is now owned by the Castalia Lions Club.

This is a view looking down a road toward the Castalia Portland Cement Mill. The mill was organized in 1898. It was located on the west side of State Route 269 (North Washington Street) opposite the Blue Hole. Vast quantities of shell marl and clay used to produce cement were dug nearby in the prairie lands, which today is Resthaven, the state game reserve.

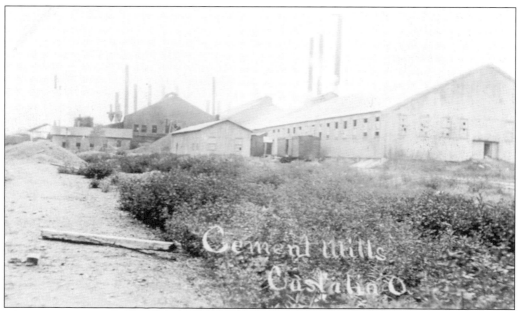

The Castalia Cement Mill was a huge operation and employed more than 160 men, most of whom emigrated from Hungary. They were housed in some buildings still standing on Cement Street. In 1906, annual capacity of Tiger Brand cement was 400,000 barrels. In 1913, high–quality white Castalia Portland cement was used in beautifying Buckingham Palace in England. Operations ceased in 1932. Cement manufacturing was a major industry in Margaretta Township.

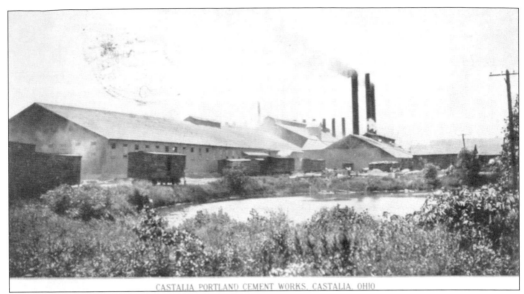

CASTALIA PORTLAND CEMENT WORKS, CASTALIA, OHIO

In 1911, Kelley Gypsum Company built a mill at the corner of Routes 269 and 6 to support the needs of the local cement plants. A private railway ran north from Castalia along the west side of Route 269. The mill closed in 1922, and the railway was removed in the early 1940s. The smaller Mad Dog Cement Mill, located near the Rockwell Trout Club, operated one oil-burning kiln and closed about 1904.

Pioneers settling in Margaretta Township in the early 1800s found an abundance of wild animals and birds. In 1990, Mona and William Rutger established their Back To The Wild 30-acre facility near Castalia for rehabilitating injured wildlife and educating schoolchildren. Since then, thousands of healthy animals and birds have been returned to the Cold Creek environment. In November 2006, Mona (holding her favorite owl) received the first-ever Animal Planet Hero of the Year Award.

Three

THE CASTALIA BLUE HOLE

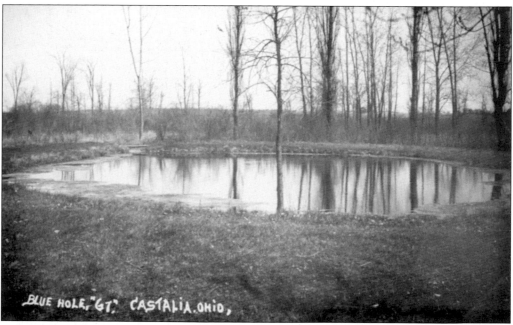

BLUE HOLE, "67," CASTALIA, OHIO,

In 1811, the dam, built on Cold Creek near the west end of Main Street to power Docartus Snow's gristmill, was entirely swept away by floods. The dam was replaced to maintain waterpower for the other Castalia mills. Pressure caused by the heightened water level in the upper pond in 1820 weakened the strata in the area of the Blue Hole, causing its collapse into the cavernous depth.

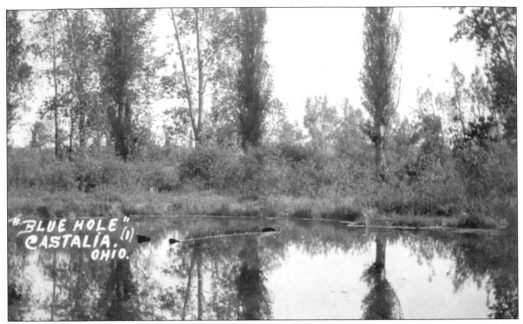

This new sinkhole spring was 12 feet in diameter and 10 feet deep. However, the Blue Hole did not gain wide publicity until about 1879 because it was inaccessible except by boat. The phenomena presented by the Castalia Springs excited considerable curiosity and interest of many people, far and wide, as depicted in this postcard cancelled in 1911. In May 1914, it was reported the water was so roily that visitors could not see beyond the surface and cave-ins were suspected.

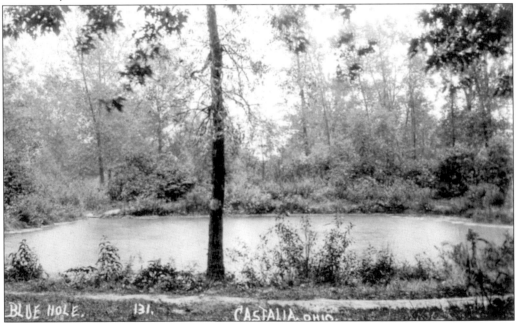

As shown in this real-photo postcard, the shrubs and trees surrounding the Blue Hole were thick and lush, which limited access to the spring. Water must have been flowing everywhere downhill toward the flour mill. A footpath used by the curious visitors can be seen in the foreground. The next 11 images cover the time period up to the commercialization of the Blue Hole in 1925.

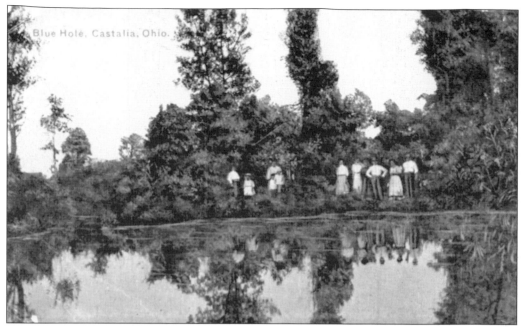

Blue Hole, Castalia, Ohio.

Over the years, many Castalia residents have retold the story about a team of horses pulling a wagon that supposedly disappeared into the Blue Hole and were never found. Some 21 variations of this local folk legend were documented by Dr. Joel D. Rudinger in his 1971 doctoral dissertation "Folklore of Erie County, Ohio." No confirming documentation proving such an incident has ever been found.

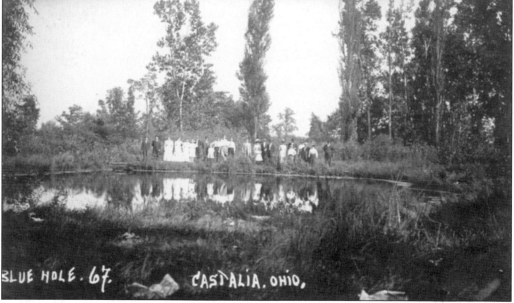

BLUE HOLE. 67. CASTALIA. OHIO,

However, one Castalia resident recalled, in 1976, that a runaway team of horses and wagon missed the bridge on North Washington Street and sank into the bottom muck of Cold Creek. This incident was reported to have happened in 1906. The soft bottom muck soil is very much the same as that of the sides of the Blue Hole. The driver, horses, and wagon were recovered. Perhaps these people are looking for the horses and wagon?

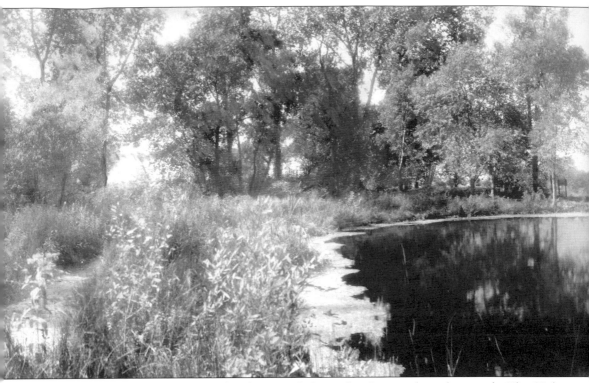

This early 7-inch-by-22-inch color photograph shows the view northward across the Blue Hole with the Castalia Trout Club house in the distance. The footpath around the edge is visible on both sides. The banks have yet to be trimmed and sloped. Algae vegetation is floating on the left side of the spring. A sign is visible to the left foreground of the clubhouse, which undoubtedly warns people from trespassing any farther onto the trout fishing grounds. With the constant

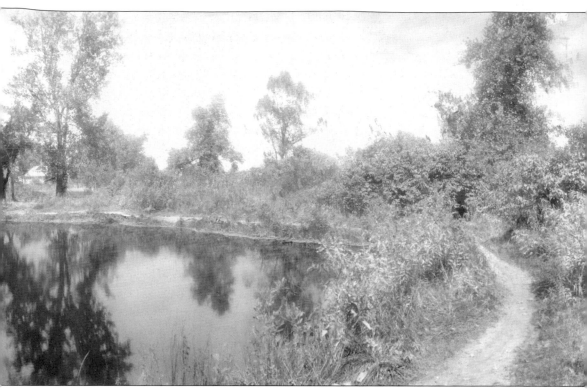

volume of water (estimated at about 5,000 gallons per minute) escaping up from the bottom of the spring, the surface remains relatively undisturbed. The sun must be shining to gaze into the depths, for the surface otherwise acts as a mirror reflecting the trees around the edge. (Mark Cloud collection.)

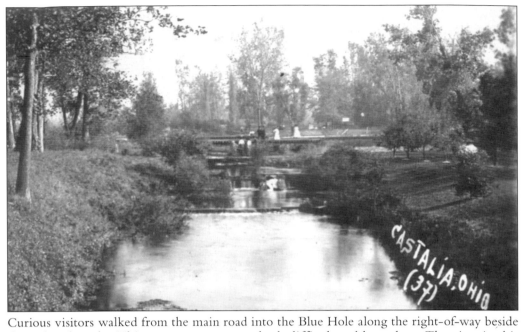

Curious visitors walked from the main road into the Blue Hole along the right-of-way beside the railroad tracks. This entrance access was both difficult and hazardous. The view in this 1914 postcard looks south toward the spring and was most likely taken from the Castalia Trout Club walkway-bridge. The groomed bank area on the right side of the club entrance road was to permit the club members to fish the stream.

Visitors could also walk down the Castalia Trout Club's entranceway from the main road to gain access to the Blue Hole, as viewed in this 1910 Ernst Niebergall postcard. The last collapse in the Blue Hole occurred in 1914, enlarging it to 75 feet in diameter and a visible depth of 45 feet. The water temperature was measured to be 48 degrees Fahrenheit at a depth of six feet.

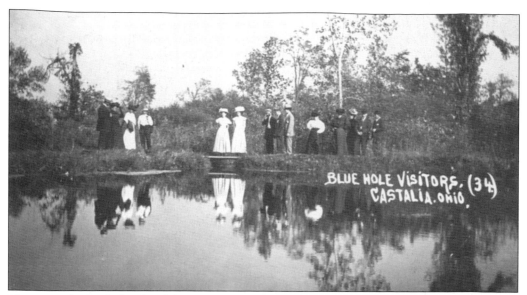

These visitors on the banks of the Blue Hole appeared to have just come from church or a formal outing. The two elegantly dressed ladies are standing on the footbridge over the outlet channel. Note their classy hats that look like big cakes. The hundreds of curious visitors left unwanted litter and trash for cleanup by the club groundskeepers.

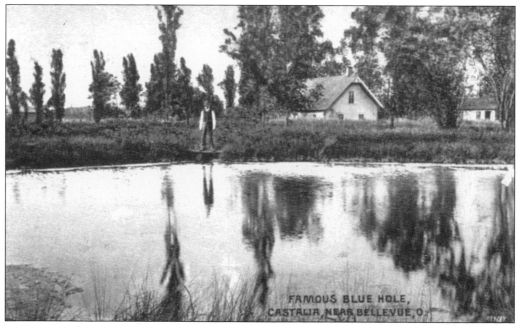

The new trout hatchery building was built in 1896. The building at the far right in this 1908 postcard is assumed to be the original hatchery. Perhaps the gentleman looking over the Blue Hole is Andrew Englert, the first club caretaker. He was an expert in all that pertained to fish culture and cared for the club property from 1890 to 1922. The guest building is visible at the far left.

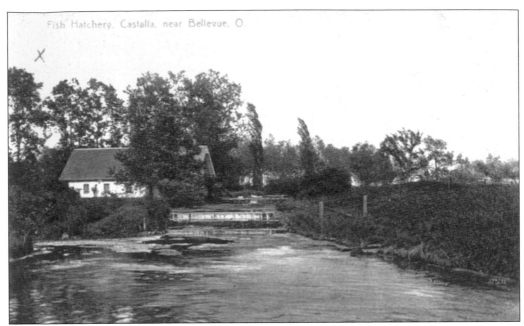

This 1908 postcard shows Cold Creek flowing from the Upper Springs in Castalia past the hatchery. A protective fence extends up the incline to the Blue Hole at the right. Near the hatchery building is a small island with the corner foundation remains of the old paper and flour mill. The mill pool water level is now about seven feet higher than it was back in 1888 when the mill burned down.

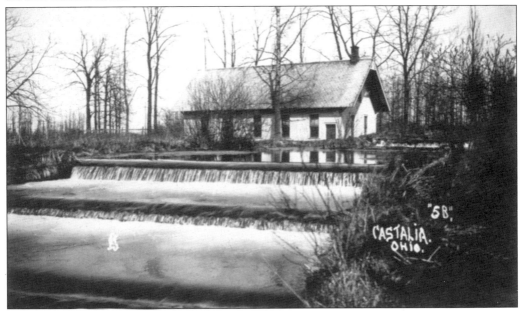

This Ernst Niebergall real-photo postcard provides an early view of the stair-step dams controlling the water flow down past the hatchery. In 1894, Andrew Englert obtained and placed in the hatchery 500,000 trout eggs and succeeded in hatching out over 400,000 young trout. The fry would be raised for at least two months before being released into the streams. This constant, low-temperature water, 47-50 Fahrenheit, was needed to enable trout to thrive.

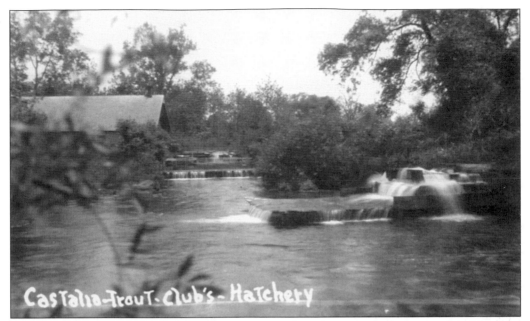

Castalia-Trout-Club's-Hatchery

On the right side is a view of the wooden chute or flume conveying the water out of the Blue Hole into the hatchery millpond. The stair-step configuration provides aeration of the water. The water flowing up out of the Blue Hole is devoid of oxygen and must be aerated to enable the trout to survive. Additional aeration is provided by numerous riffle dams farther on down the stream.

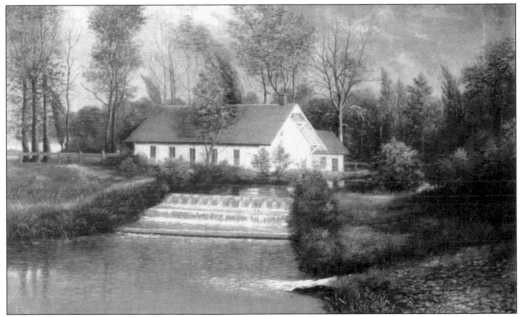

Sandusky artist Ralph Tebbutt (1849–1930) painted this scene of the trout hatchery building probably in the early 1900s. The smaller building on the right side is the original hatchery building, which was removed in later years. The wooden chute does not appear in the foreground in this 23.5-inch-by-36-inch color painting. (From the collection of the Sandusky Library Follett House Museum.)

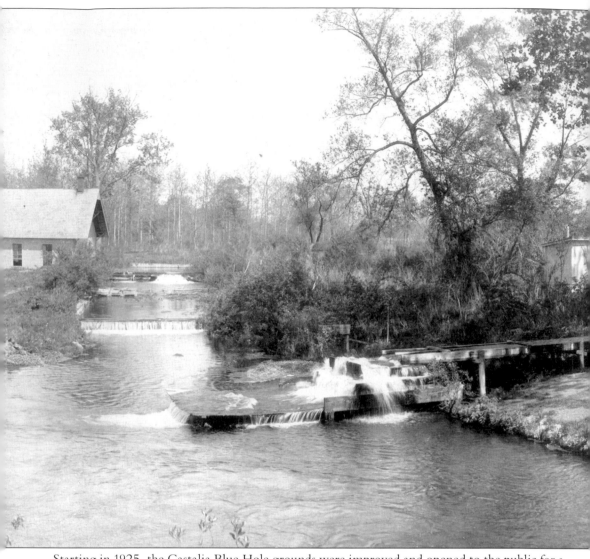

Starting in 1925, the Castalia Blue Hole grounds were improved and opened to the public for a modest admission fee of 10¢. The Castalia Trout Club leased the tract of ground encompassing the Blue Hole to Leonard Hacker and Clair Goodwin in 1925. They were to receive a percentage of the net receipts. They subsequently erected a fence around the spring, added footbridges along the stream, put in cement walkways, and installed numerous benches and tables and a refreshment

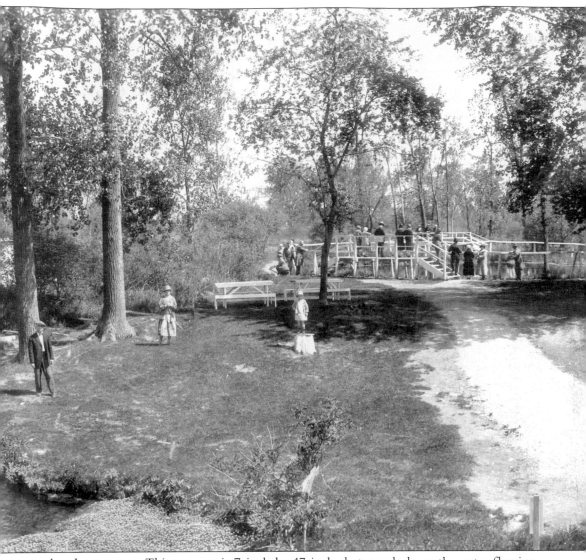

stand at the entrance. This panoramic 7-inch-by-17-inch photograph shows the water flowing from the Blue Hole via a wooden spillway and cascading into the millpond in front of the fish hatchery building. Two observation platforms were built to enable the visitors to gaze into the enchanting depths of the spring. Comfort stations are visible behind the trees. It appears that the visitors always dressed up to come to this natural beauty spot. (Mark Cloud collection.)

This photograph of the author's grandfather Charles E. Johnson (1857–1928) shows the Blue Hole entrance sign on the newly erected wooden fence leading into the commercial attraction. For many years the Blue Hole was promoted as "Ohio's Greatest Natural Wonder." (Paul Kuebeler collection.)

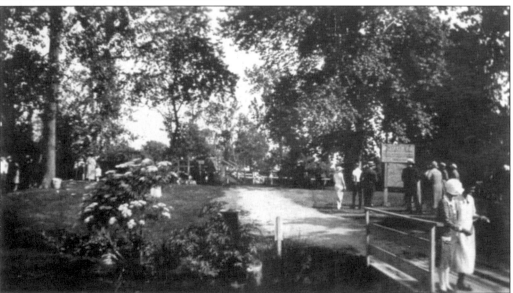

The footbridge leading to the Blue Hole crosses over the Blue Stream coming from around behind the Blue Hole and flowing into the millpond. The flow rate of the spring was reported to be 5,000 gallons per minute, but this might have been exaggerated. The water pressure at the bottom was estimated to be 20 pounds per square inch, or 3,000 tons of water. The signboard on the right announces park restrictions and a history of the Blue Hole.

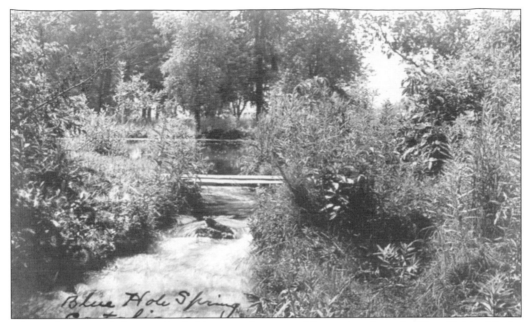

This early postcard shows a footbridge crossing one of the outlets from the Blue Hole with the heavy vegetation surrounding the spring. The earliest known souvenirs, as shown in a following image on page 74, are identified as from the Blue Hole Spring, as captioned on this card.

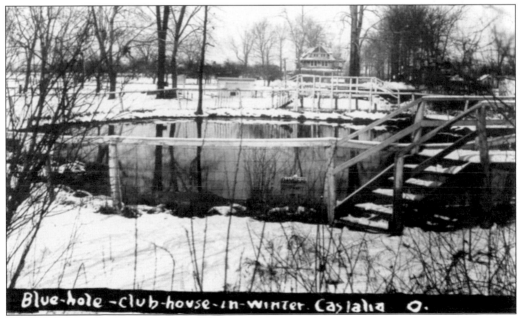

This winter view looks north toward the clubhouse. This original fence is a wooden frame structure covered with wire mesh. The sign behind the fence in the foreground reads Danger Keep Away. The edge of the Blue Hole was soft, mushy soil and could easily give way to the curious visitor. No reports have been found about anybody falling into the Blue Hole.

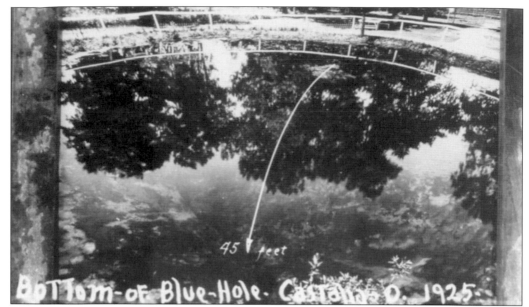

The Blue Hole spring was known as an American Indian medicine camp many years ago, before the white pioneers came to the Castalia area. This 1925 real-photo postcard indicates the visible bottom to be 45 feet deep. Contrary to prevalent belief that the depth was unknown, it was documented in 1932 that soundings were made showing the depth to be 43 to 45 feet. Reflections of trees in the water make it difficult to distinguish any vegetation growth.

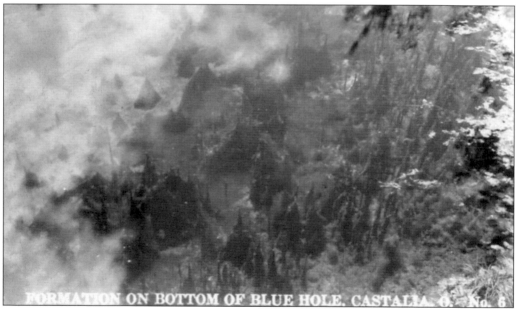

Stalagmite-like growths of grey-green algae project upward from the slimy sidewalls of the Blue Hole and can be seen to great depths. The iridescent colors change depending on the angle of the sun and the weather conditions. It gives the appearance of a fairy landscape. This vegetation growth is also readily visible at night when lighted by the floating lily pad. This late-1920s postcard (number six) is one of a series published by C. C. Messmore of Lorain.

54

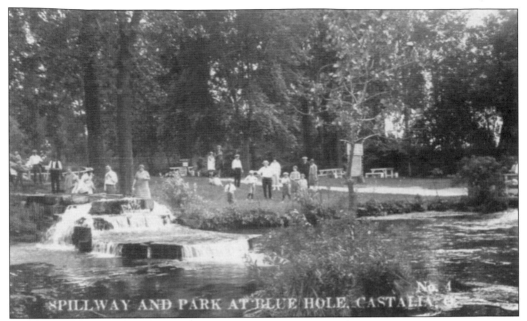

The Blue Hole is a truly remarkable natural wonder. It is a great spring of sparkling, clear blue, cold water, forming a surrounding natural paradise for rainbow and speckled brook trout and a sheltering place for all kinds of wild birds. It is a mecca for the tourist and the photographer. Visitors could eat their lunch under a willow tree or a cottonwood. It is the end of a perfect day. This is Messmore real-photo postcard number four.

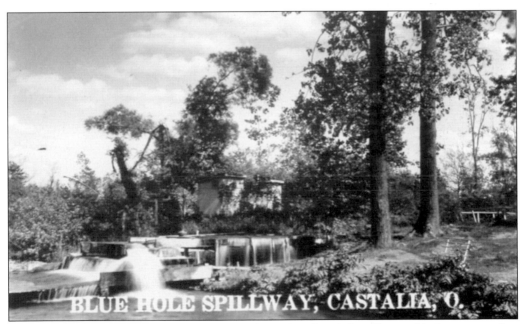

Another 1930s Messmore real-photo postcard shows the Blue Hole spillway with the two comfort stations in the background. The fence around the Blue Hole is visible at the far right. The new entrance roadway and parking lot were constructed in 1930, replacing the old entrance along the railroad right-of-way. It was reported that over 165,000 people visited the site during 1936.

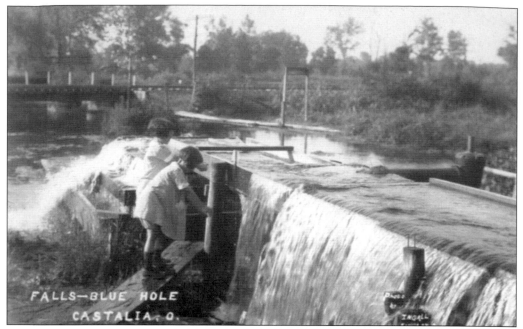

FALLS—BLUE HOLE
CASTALIA, O.

This interesting real-photo postcard shows two young girls playing around the spillway from the Blue Hole. This had to have been a dangerous situation where they could have been swept into the millpond. So where were their parents? Probably gazing into the Blue Hole. This photograph was taken by Ingall of Findlay. The railroad bridge is visible in the background along with a footbridge for the club's fishermen.

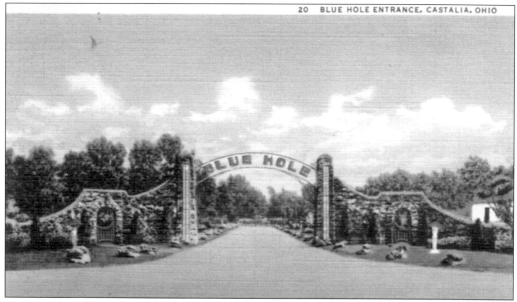

The next 36 Blue Hole postcards are arranged by various scenic spots spanning the years from 1940 to 1990, when this popular tourist attraction was finally closed to the public. These postcard views should hopefully bring back many memories to the readers of this book. Entering the Blue Hole Park from the main road, State Route 269 or North Washington Street, the visitors passed through this famous tufa-rock archway, constructed by Charles Eggert in the early 1930s.

ENTRANCE TO THE BLUE HOLE, CASTALIA, OHIO. N323

The wooden gates on each side were really for decoration and were never used. The asphalt roadway leads to a large parking lot for the hundreds of automobiles that came in. The park was electrified in 1933. The big Blue Hole letters in the metal arch framework were illuminated every day at dusk until the park closed at 11:00 p.m. Vertical colored lights were located on the two columns supporting the arch. In later years, words were added to these lights announcing on the left side "Enjoy A Family Picnic," and on the right side "With Fun For Everyone." During the open season, mushroom-looking pedestal lamps lined the entrance road along with large hunks of local tufa rock. Swing metal gates closed off the entrance archway during the closed hours. Trees and shrubs along the entrance structure had to be periodically pruned back, as evidenced in the bottom postcard.

Entrance to Blue Hole, Castalia, Ohio

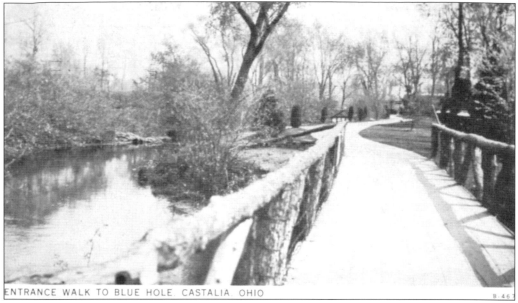

ENTRANCE WALK TO BLUE HOLE, CASTALIA, OHIO

Visitors next strolled along the entrance walk or scenic promenade to enter the park. A wooden bridge with natural log railings crossed the Blue Stream teeming with large hungry trout. The stream was water flowing from the Blue Hole in a zigzag pattern behind the parking lot and eventually into the millpond. The serpentine-shaped stream was for exclusive trout fishing by the Castalia Trout Club members. The main walkway was paved with concrete, although there was a dirt pathway close to the stream for closer views of the trout. This walkway was only a short distance to the admission gate in the log cabin. Blue Hole postcards were distributed by E. B. Ackley and Rich-Holt Company, both in Sandusky. The entranceway lamps and lights were scrapped after the park closed in 1990.

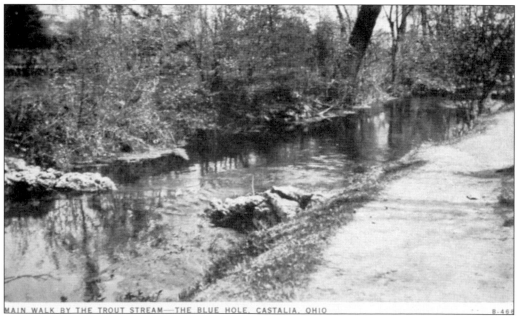

MAIN WALK BY THE TROUT STREAM—THE BLUE HOLE, CASTALIA, OHIO

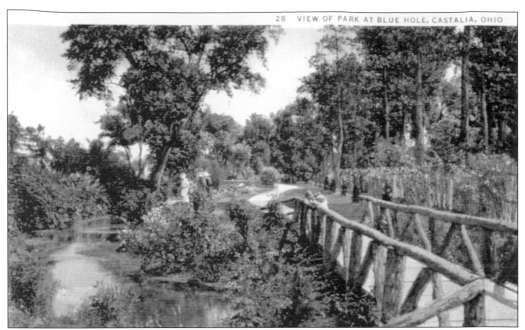

While the entrance walkway was attractive, it was probably never quite this heavily flowered as shown in the above postcard. The author worked on the summer maintenance crew during the early 1950s and does not recall this abundance of bright colored flowers. It took a lot of hours to rake the moss and floating vegetation out of the streams and the Blue Hole. The rustic bridge was inside the park and provided the visitors an opportunity to watch and feed the trout. The bottom postcard shows the water flowing between built-up rock sidewalls to provide further aeration of the water. In the 1950s, tourists' automobiles were lined up almost one mile waiting to enter the park. The Blue Hole property continues to be owned by the Castalia Trout Club.

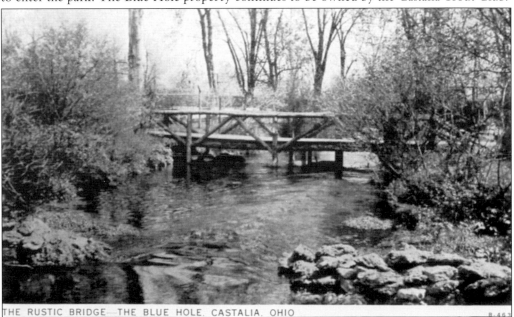

THE RUSTIC BRIDGE—THE BLUE HOLE, CASTALIA, OHIO B-463

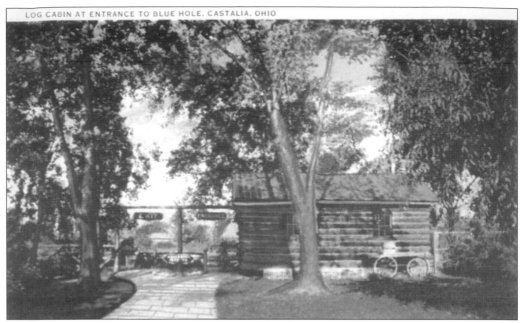

The log cabin, built in 1925–1926, includes the visitor admission turnstile. This early color postcard, published by Blue Hole manager R. J. Woolson, shows a sign listing the admission price of 10¢. There is an old wagon parked on the right side, perhaps to convey refreshments to the cabin. This building was also used as a refreshments stand, selling food, souvenirs, and fish food from the windows on the back side. The walkway appears to be made of concrete paving blocks. In the bottom postcard, the admission price has increased to 15¢. A decorative plantlike lamp has been installed at the right. An early-1940s newspaper account reported attendance records were broken during the Labor Day weekend with 6,222 admissions on two days, including over 800 at night.

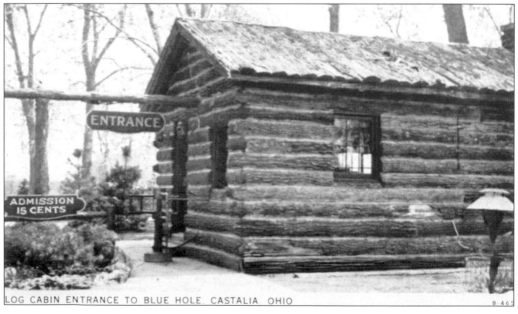

LOG CABIN ENTRANCE TO BLUE HOLE, CASTALIA, OHIO

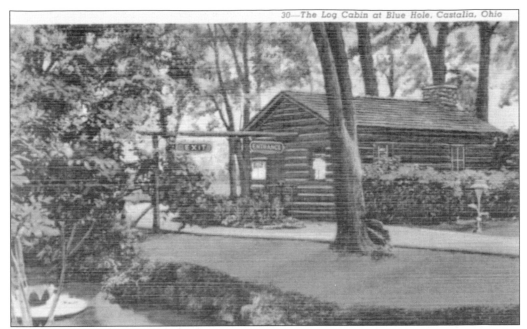

The top color postcard shows a manicured lawn along the walkway. In the stream is a floating metal lily pad concealing lights underneath that illuminated the stream at night. In the bottom postcard, the log cabin has now been covered with red cedar siding. The walkway has been replaced with cast concrete. It appears that the lawn has been replaced with gravel due to the heavy foot traffic. Blue Hole brand honey was sold at the park, and the producer had a demonstration working beehive near the cabin on the right side. A wooden tube connected the hive to an exit opening near the shrubs further away so that the airborne bees would not endanger the visitors. The rustic bridge is visible on the left.

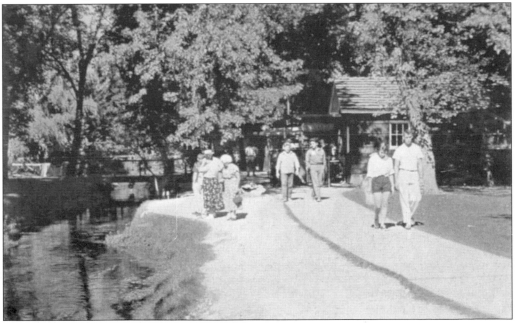

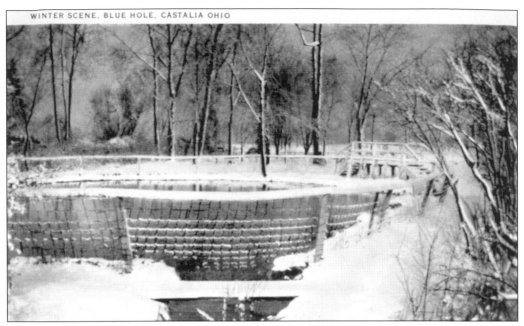

WINTER SCENE, BLUE HOLE, CASTALIA OHIO

While not open to visitors from November to early April, the Blue Hole provided some beautiful snowy winter scenes. This color postcard by manager Woolson shows the wire mesh fence around the spring with an observation platform in the background. The bottom postcard shows a rustic log construction fence with an outlet for the water. Floating in the center is a metal lily pad with underneath lights. Unconnected to this Blue Hole is Miller's Blue Hole near Vickery, which is the area's largest sinkhole spring. It is 500 feet in diameter and 30 feet deep, with an outflow rate of around 1,800 gallons per minute.

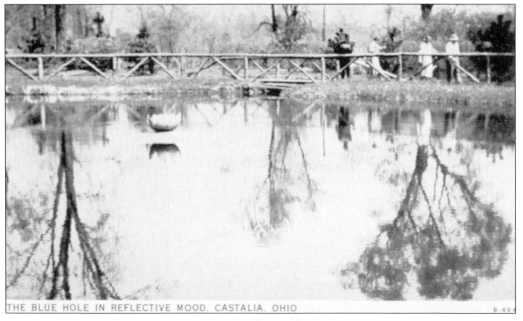

THE BLUE HOLE IN REFLECTIVE MOOD, CASTALIA, OHIO B-464

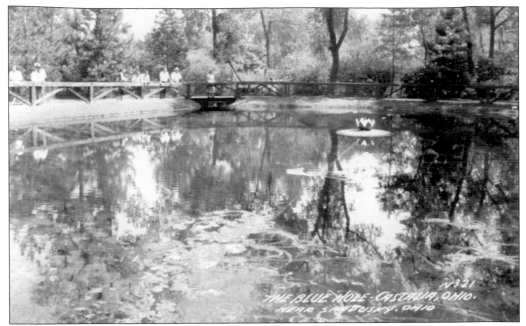

The top real-photo postcard shows the floating lily pad held in the center of the Blue Hole by cables. The numerous floating lights were fabricated by the Gundlach Sheet Metal Works in Sandusky. The pads were taken out of the water during the winter. Algae vegetation is floating on the water in the foreground. The luxuriant growth of microscopic plant life around the upper sidewalls gives iridescent colorization; it is a weird view, mysterious and amazing. The wooden fence has been replaced with sawn timbers and boards. The bottom color postcard is an aerial view of the Blue Hole taken by Mound Photography and distributed by George Tremper, both of Sandusky. The small aerating waterwheel can be seen behind the outlet at the upper left.

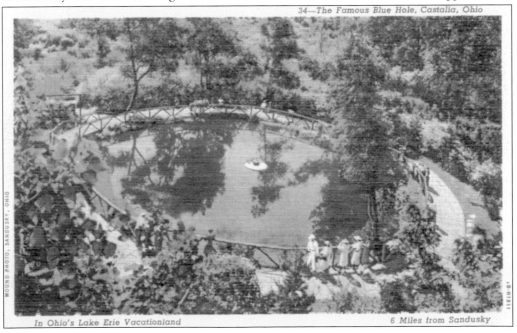

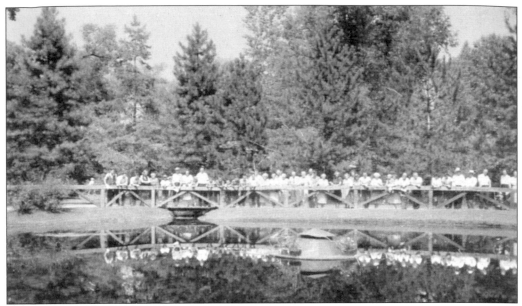

Early promotional brochures advertised the Blue Hole as the "most extraordinary artesian spring in the continent." In the clear depths of the apparently motionless water, the visitor sees a myriad of strange formations, varying from the flowing white beard of hoary-haired giants to the rich blue of snow-covered Alps. It is viewed as a magic place. The floating light fixture in the center has been replaced by a cone-shaped structure. Below, this four-foot-diameter metal sign advertised the Blue Hole. These roadside signs were located on the main roads throughout Erie County and adjoining counties that led to Castalia. They were nailed to telephone poles and sides of buildings. When the Blue Hole closed to the public in late 1990, these signs were retrieved by the advertising sign company. This particular sign is on display in the Heritage Society of Erie County museum barn at the Erie County Fairgrounds in Sandusky.

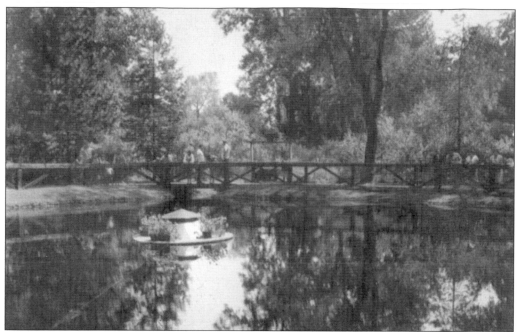

These are two later-period color postcards of the Blue Hole. The top card is postmarked 1977 and shows potted plants on the center float. Reflections of the surrounding trees darken this image. The bottom card is judged to be from the 1980s. The comfort station is barely visible in the background. Tourists were attracted to the Blue Hole to gaze in wonder at the strange sights in the depths of the crystal clear water, much as the American Indians were no doubt attracted to the Castalia Upper Springs. Submerged tree trunks and roots are visible in the soft, marl-soil sidewalls. The spring was a mysterious icon for the children.

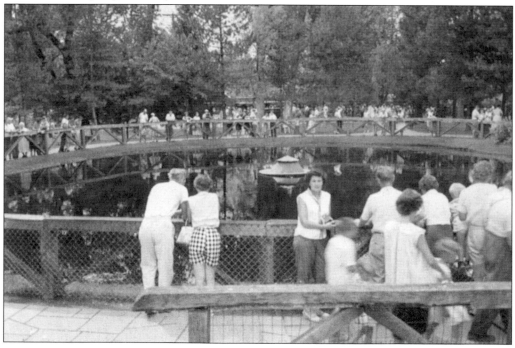

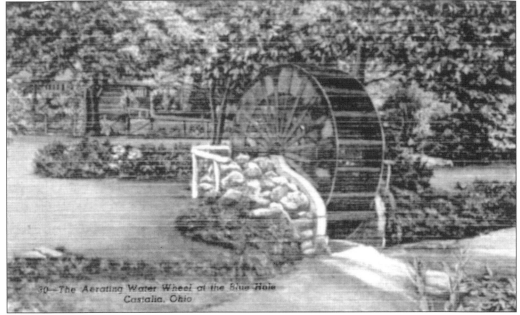

30—The Aerating Water Wheel at the Blue Hole
Castalia, Ohio

Here is the large-diameter, wooden aerating wheel located next to the hatchery building. Stream water flowing from behind the hatchery turns the wheel as it dumps into the stream headed to the millpond. Farther downstream, the Castalia Farms Trout Hatchery reported in 1973 that its aerators increased the oxygen content in the Cold Creek water to a minimum of six parts per million as necessary to sustain trout life. In the top postcard, the comfort station is visible in the left background. Large tufa rocks are piled around the base. After rotating for many years, the wheel is currently stopped due to the water flow having been shut off. A local resident reported that the wheel had been rebuilt by Lynn Rogers, who once lived next to the Blue Hole entrance.

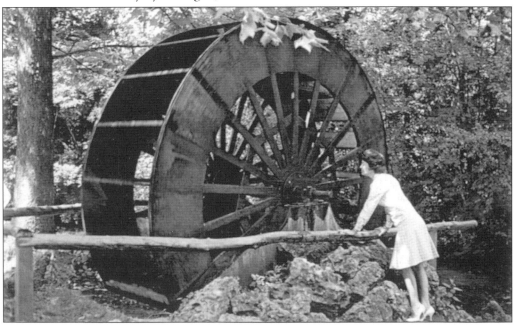

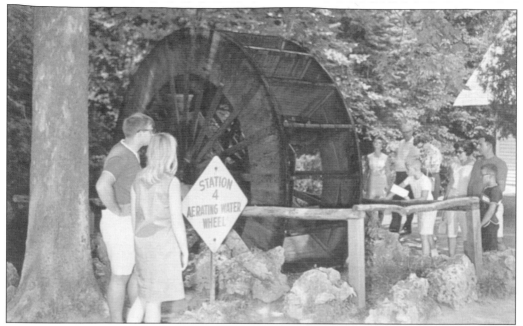

Sometime in the 1960s, identification station signs were placed around the park for the benefit of the visitors. Upon paying the admission fee, each visitor received a guide brochure that identified the eight different stations, number one being the Blue Hole itself. In the bottom postcard, in the left background can be seen the log cabin refreshment building. The picnic area is to the far left behind the log cabin. The small building toward the center of the postcard housed a colorful and fact-filled exhibit depicting the life cycle of a trout from egg to adult, including some mounted big ones. Displayed were brown, rainbow, speckled, and tiger trout, which inhabit Cold Creek all the way north to Venice.

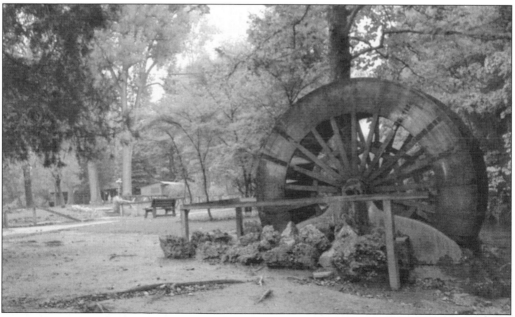

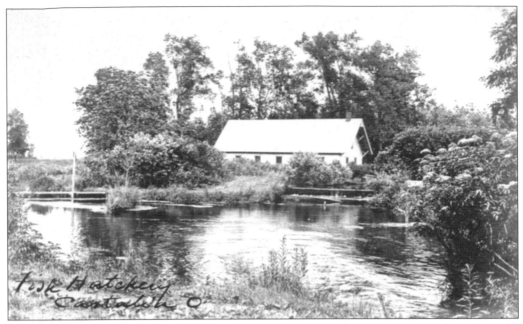

Fish Hatchery Castalia O.

The trout hatchery building was open to the public for several years, but it was found that the tiny trout hatchlings were very susceptible to the wrong food, excitement, and disturbance from the visitors, so park management reluctantly decided to close the building. Trout spawn and the eggs hatch in the wintertime so it was almost impossible to demonstrate the trout reproduction process during the open season for the park. The rainbow, brook, and brown trout observed in the streams were hatched here. The bottom postcard shows the stream flowing from the Blue Hole around the back of the building. Water flows under the aerating wheel and out through an underground conduit to empty into the stream shown in the opposite bottom postcard.

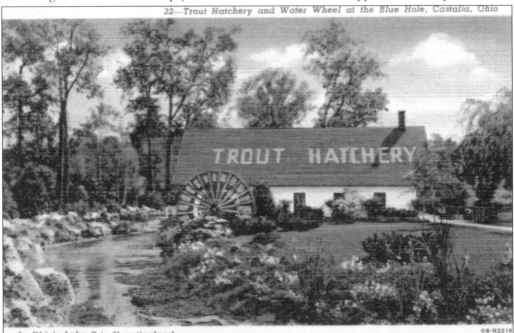

32—Trout Hatchery and Water Wheel at the Blue Hole, Castalia, Ohio

TROUT HATCHERY

In Ohio's Lake Erie Vacationland

OB-H2519

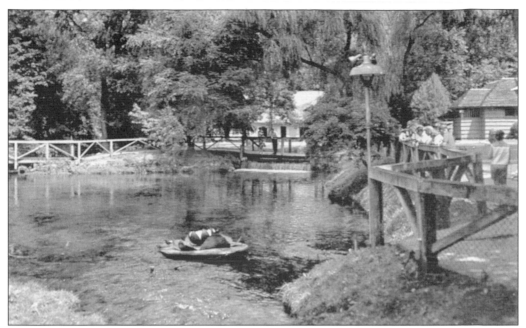

The millpond was the best location to observe the big trout by coaxing them to the surface with fresh popcorn from the log cabin refreshment window. The water churned with the hungry trout snapping up the food. Bread was another acceptable food, but popcorn was a real moneymaker for the park. Because fishing was not allowed inside the park, the trout became quite tame and easily attracted by feeding them. Visiting fishermen must have drooled over the sight of these huge trout and wished for a fly rod to do some angling like the trout club members. The building on the right side is the comfort station. The lights under the floating lily pad created a nighttime spectacle with all the trout swarming around underneath.

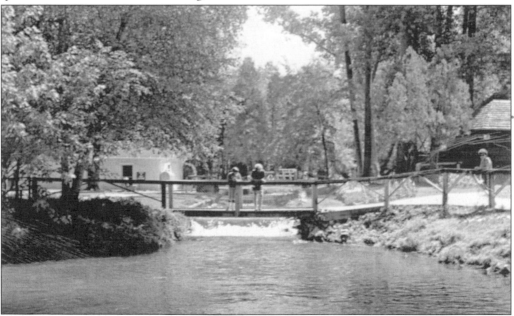

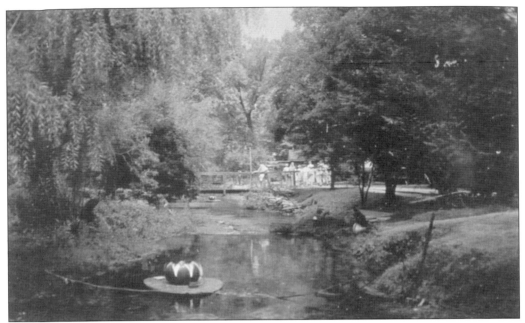

The top postcard view is looking down the stream along the entrance promenade. These are two more cards distributed by Rich-Holt of Sandusky. The Blue Hole was included in *Ripley's Believe It or Not!* as illustrated in a 1944 edition of the *Boston Globe* newspaper. It was cited as the "mysterious and colorful body of water in Castalia, Ohio." Attendance levels had dropped significantly in the 1990s due to other local attractions such as the extremely popular Cedar Point Amusement Park. Only 25,000 people visited the park in 1990, as compared to a peak of almost 150,000 visitors in the 1940s.

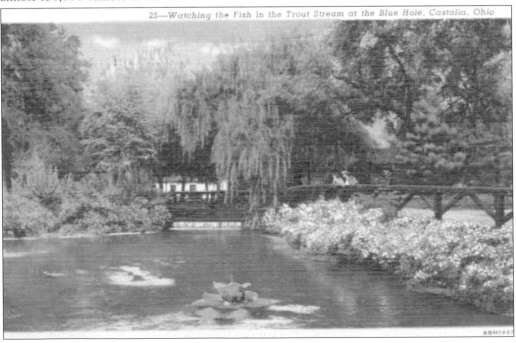

25—Watching the Fish in the Trout Stream at the Blue Hole, Castalia, Ohio

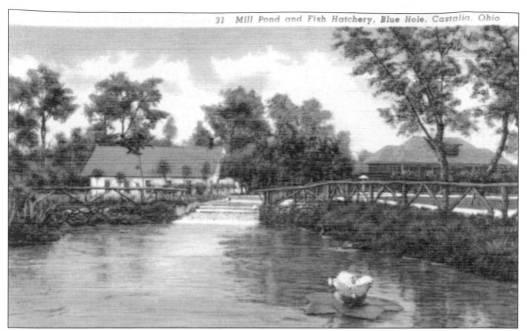

The building on the right side of these postcards is the comfort station provided as a necessary service to the visitors. This building replaced the two separate small facilities shown in the previous early images. The fence and bridge railings provided excellent resting spots while checking out the trout. Admission fees to the park continued to increase periodically over the original 10¢. When the Blue Hole closed for good in late 1990, the fees had risen to $2 for adults and $1 for children. The Castalia Trout Club made the decision to close the park because the entrance fee revenues had dropped to less than the operating costs. To upgrade some of the buildings and equipment, dating from the 1940s, would have required additional investments that the club could not justify making.

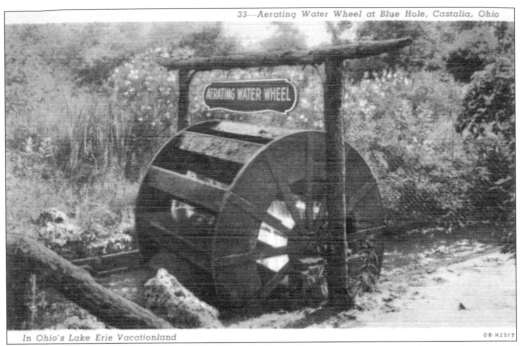

In Ohio's Lake Erie Vacationland OB-H2517

The top postcard, postmarked in 1945, shows the small aerating waterwheel located in one of the outlets just behind the Blue Hole. Visitors enjoyed throwing coins into the Blue Hole and the two outlet streams to watch the coins slowly flutter down to the bottom. The maintenance crew had to mow the grass on the bank inside the Blue Hole fence, so they had opportunities to fish out many of the coins near the edge. The local banks readily recognized the source of these coins since the dissolved free carbonic acid and mineral salts in the water rapidly tarnished the coins black and green. Nighttime provided a gorgeous fairyland.

The wooded picnic area behind the log cabin was a popular family spot. Charcoal grills for cooking were available along with numerous tables. This pleasant, well-shaded area also contained swings and rides for the enjoyment and use by children of any age. It was an ideal place to spend a relaxing afternoon with family or friends. In 1937, concrete basins were built alongside the hatchery building. One of these basins typically held these Lake Erie goldfish, or carp, which loved to snap up popcorn. Young trout were raised in one of the basins. These basins no longer exist except for the outer walls.

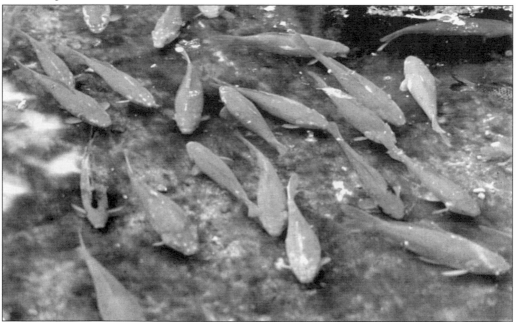

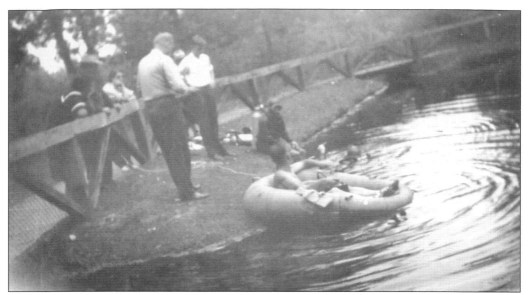

For years, the prevalent belief was that the Blue Hole was bottomless, and only the visible depth was known to be 43 to 45 feet, maybe 60 feet. In the late 1950s, divers failed to reach the bottom due to the narrowing sidewalls. Trout club manager Everett Reeves (center) is observing. A local newspaper reported in 1984 that divers had been down to 60 feet and found only a rock bottom with many small holes. (Bud Felske collection.)

Between the years 1925 to 1990, thousands of Blue Hole souvenirs were carried away by the many visiting tourists. These earliest-identified porcelain souvenirs are marked "Blue Hole Spring Castalia Ohio," and depict the Blue Hole surrounded by a fence. These early multicolored souvenir items were manufactured in Germany. Each season, new varieties of souvenirs, many made in Japan, were added to the log cabin's inventory. (Robert Wolfbrandt collection.)

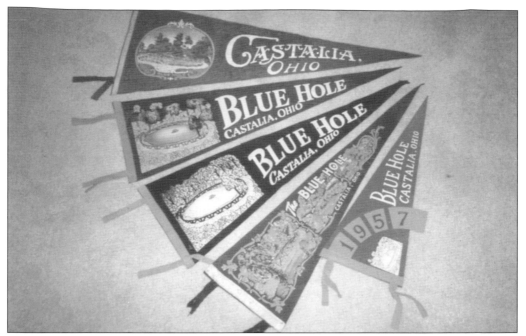

Multicolored, felt souvenir pennants were big sellers, depicting different scenes from the Blue Hole Park. Sizes varied from 8 inches to 28 inches long, while some included dates like the variety from 1957 shown in this photograph. These must have adorned many young tourists' bedroom walls. The author's collection includes some 25 different designs.

Ceramic, glass, metal, wood, fabric, paper, and plastic souvenirs of all kinds promoted the Blue Hole over the 65 years of commercialization. These included plates, dishes, cups and saucers, ashtrays, wall plaques, mugs, steins, paperweights, jewelry boxes, drinking glasses, vases, figurines, music boxes, compacts, letter openers, and trinkets of all kinds bearing the Blue Hole logo. This photograph shows a variety of salt and pepper shakers, with a pair of fish "nodders" in the lower right. (Robert Wolfbrandt collection.)

The log cabin was the admission gate, souvenir stand, and snack food facility. This *c.* 1970 photograph shows the inside display shelves and counters packed with souvenirs awaiting the happy shoppers. The walls were festooned with wooden souvenir plaques of wildlife pictures and religious items. Chinese dragon-ware ceramic souvenirs and American Indian–like items were popular sellers. The log cabin was managed for many years by Betty Biglin. (Paulette Biglin collection.)

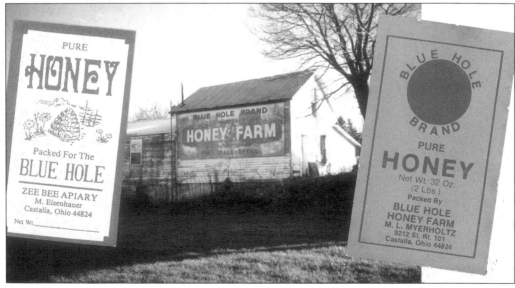

Blue Hole brand honey was sold by two Castalia producers. The Zee Bee Apiary was operated by Milton "Zeke" Eisenhauer. His 50,000–100,000 bees produced over 5,000 pounds of honey each summer. He sold honey from a stand along the entrance walkway into the Blue Hole. Melvin Myerholtz produced various wildflower-flavored honey from 1957 to 1987 at his State Route 101 farm. His honey was sold in retail outlets, roadside markets, and health food stores.

Four

TROUT FISHING CLUBS

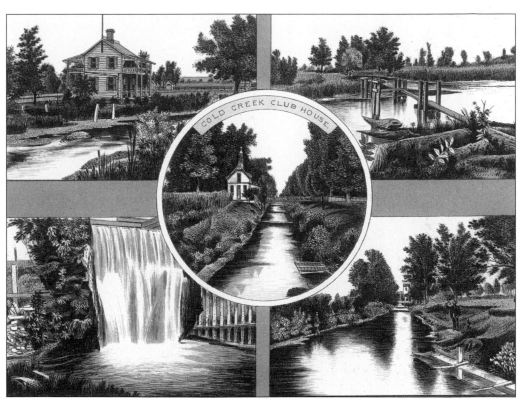

This page from an 1890s souvenir booklet of Sandusky depicts early illustrations of the Cold Creek Club House. On the upper left is the Cleveland Club, which later became the Castalia Sporting Club. In the center, is the original clubhouse, built in 1879, of the current Castalia Trout Club with the bridge over the creek, looking north. The lower right view is looking south toward the clubhouse. The falls (lower left) appear to be substantially higher than currently exist.

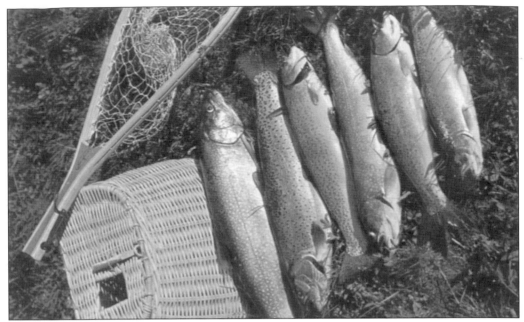

In 1868, John Hoyt, owner and operator of the Castalia Paper Mill, introduced speckled brook trout into Cold Creek by importing eggs from an eastern stream. Trout were not indigenous to Ohio waters, but they thrived in the year-round cold water. In several years, Cold Creek became stocked with plentiful trout. Fishermen from Cleveland and other cities soon discovered the excellent fishing opportunities of Cold Creek. This Blue Hole postcard shows "a good day's catch."

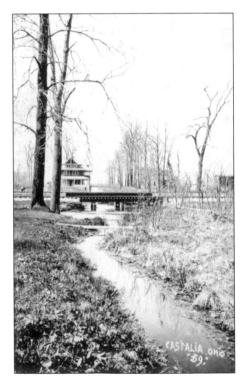

In 1879, the Cold Creek Trout Club Company was incorporated. The waters, owned and controlled by the Castalia Milling Company, were leased for the sole privilege of sport fishing and propagating fish. Capital stock was divided into 85 shares. A neat and comfortable clubhouse fronting on the Race was erected about 150 yards below the mill and railroad tracks. Water from the Blue Hole is shown flowing north under the railroad tracks.

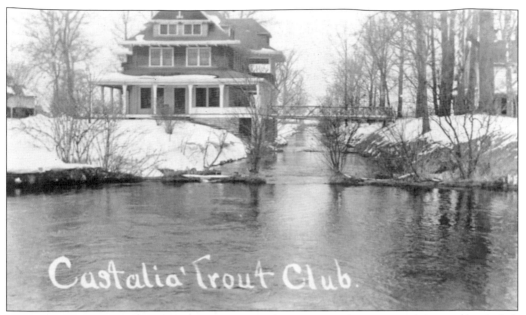

Castalia Trout Club.

In 1886, this "Upper Club" was reorganized as the Cold Creek Sporting Club Company with 75 shares of capital stock. This club then purchased the entire property, water rights, and dams of the Castalia Milling Company. In 1890, the corporate name was changed to the Castalia Trout Club Company, the present name. The old mill was torn down, and improvement of the property for the anglers began in earnest.

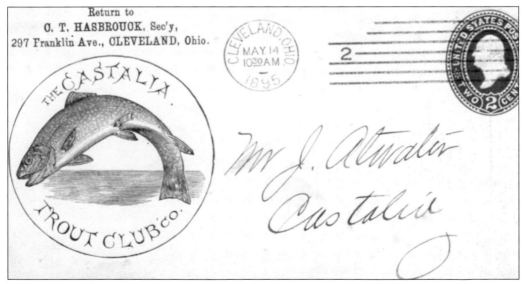

This 1895 cancelled envelope portrays an early club logo. The current clubhouse was greatly enlarged and beautified in 1894 by George Feick, a Sandusky contractor. The two-and-one-half-story building with a slate roof contains three large rooms on the main floor: a reception room, a reading room, and a room for the care and preservation of trout. The upper portion of the house is divided into sleeping rooms for visiting members.

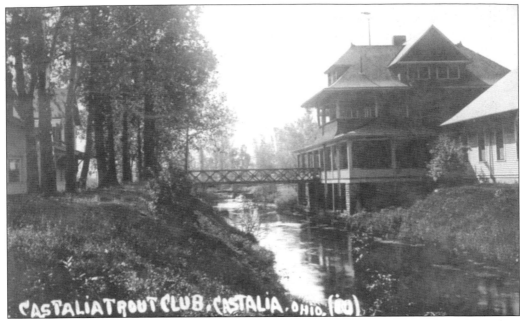

This 1911 view looks south, showing the ornamental iron bridge crossing over to the building containing the kitchen, dining room, and some sleeping rooms. Currently the club manager's office and living quarters are in this building. The smaller building on the right contains several suites of rooms for the wives and families of the members. The clubhouse originally contained an immense ice chest fitted with galvanized iron trays to store the trout until taken home or shipped.

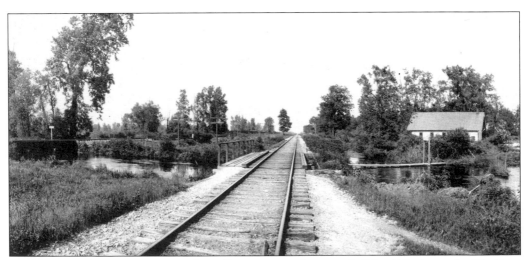

This portion of an early Ernst Niebergall panoramic photograph (No. 137) shows the Big Four railroad tracks looking northeast. To the left is the other parallel set of railroad tracks. On the right is the trout club's fish hatchery building and millpond. Farther to the right is the Blue Hole. Note the narrow footbridge crossing the creek. (Hayes Presidential Center.)

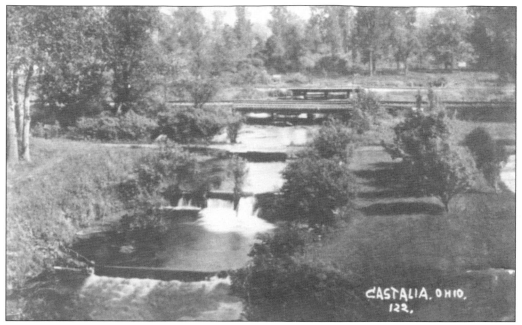

Here the view is looking south across several dams toward the Blue Hole in the distance surrounded by trees and bushes. The nearest railroad trestle bridge is for the Nickleplate Railroad. This photograph was taken from the bridge at the clubhouse. Pres. Grover Cleveland frequently visited the club to fish. In 1893, he was made an honorary member for one year.

This real–photo postcard is titled *Blue Stream* and looks west to where the Blue Stream, dug in 1891, enters the millpond. Just to the right of the stream can be seen the end of the old flour mill situated along the railroad tracks. The Castalia Cement Mill is barely visible in the background. Tiger trout, first introduced in 1960, were successfully developed by crossing female brown and male brook trout.

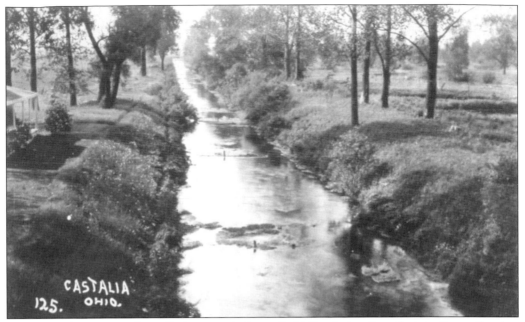

CASTALIA
OHIO.
125.

Another early Ernst Niebergall photograph shows Cold Creek, locally called the Race, flowing north past the guesthouse on the left. All this water is coming from the Blue Hole combined with that from the Castalia Upper Springs. Periodic riffle dams are visible. These are to help maintain the desired stream levels as well as to aerate the water. This Race travels straight to the club's northern property boundary with the Castalia Sporting Club, or the Lower Club.

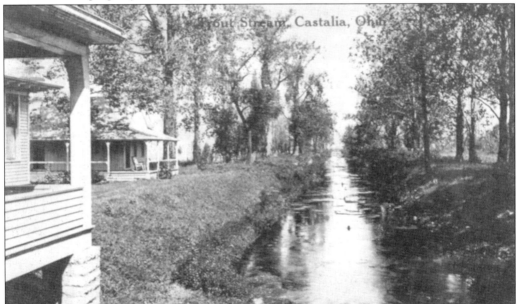

Trout Stream, Castalia, Ohio

Seen here is another view showing the Race headed north. The building seen just past the clubhouse porch is the guesthouse, also called the squaw camp. Andrew Englert was the first club caretaker, from 1890 to 1922. At the end of a hard day's fishing, the members gathered on the porch to socialize and enjoy the onetime famous Castalia Club Rye, supplied solely for the club by the Bergin and Brady Company of Columbus.

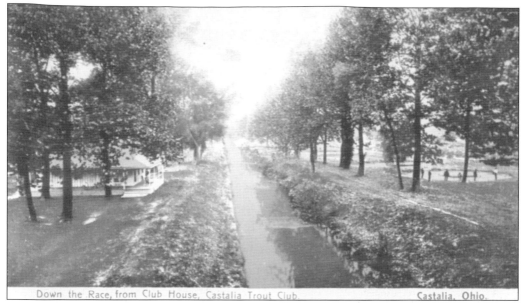

Down the Race, from Club House, Castalia Trout Club. Castalia, Ohio.

Off to the right are three oval-shaped pools, which were known as coffins. They were used to grow trout fingerlings during the time period between the hatchery and the nursery section. In 1889, the club purchased 56 acres of land to the east of the tailrace and dredged out a very crooked watercourse, forming great loops about 100 feet apart, along with rapids, pools, and hiding places for the trout.

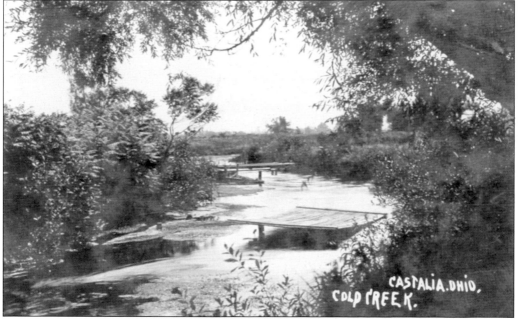

CASTALIA, OHIO.
COLD CREEK.

The new, serpentine-shaped Cold Creek trout stream was generally 20 feet wide and had numerous little plank bridges, as can be seen in this real-photo postcard. There were occasional wooden platforms to provide hiding spots for the wary trout. The club now has six-plus miles of continuous, fast-flowing stream on 104 acres. With these plank bridges, an angler can nearly walk a straight line in 10 minutes back to the clubhouse.

83

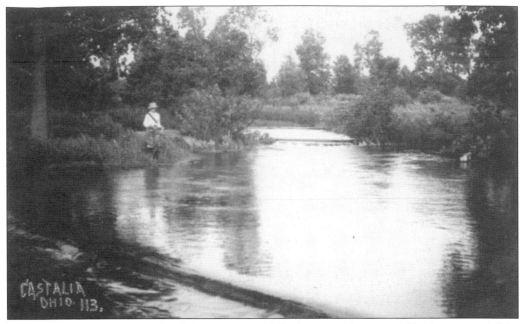

This trout club member is fly-fishing in one of the large pools. Two riffle dams are visible. The stream is surrounded by sycamore, elm, cottonwood, and maple trees, which shade the fishermen. Prolific vegetation along the stream includes mint, watercress, and a fine moss. This moss is alive with freshwater shrimp, sticklebacks, and numerous crustaceans, which provide a wonderful food supply for the trout.

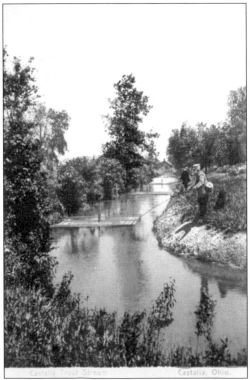

Members can only fish with rod, line, and artificial bait. Only trout greater than eight inches in length may be taken from the stream. Each member is limited to a daily total of 10 pounds. The frequently disturbed trout become very wary and quite difficult to catch. The fisherman needs a thorough knowledge of the habits of the trout and a skillful manipulation of his equipment to land the big ones.

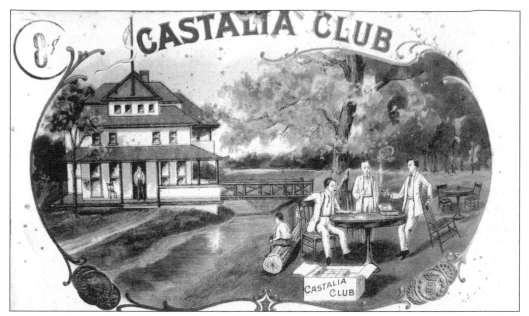

How about an 8¢ Castalia Club cigar? This is a rare, colorful, 5-by-8-inch cigar box label. These Castalia Trout Club members are enjoying their smokes after a vigorous day of fishing in the Race. The Castalia Fishing Club was the namesake for the 380-foot-long steamer *Castalia*, launched 1889 in Cleveland. It sank in the Atlantic Ocean in 1919. (Mark Cloud collection.)

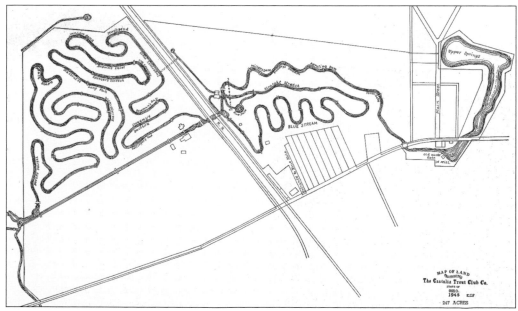

This 1945 map of the Castalia Trout Club Company's 247-acre site diagrams the "most crooked water course in existence." The club currently owns the Upper Springs, also known as Castalia Duck Pond, and the Cold Creek stream to the northern boundary with the Owens–Illinois Farms property. Sections of the stream are identified with the names of some early prominent members.

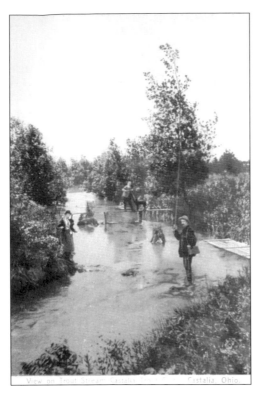

Check out these happy fishermen and what looks like a woman in a skirt on the left. In the early days, women were only allowed to fish during June through August in a limited area of the stream. The member fishing from the narrow plank bridge has his dog with him, maybe to help carry his catch to the clubhouse. In 1894, a total of 5,889 trout were caught, weighing 2,269 pounds. The record was an 8.5-pound German brown trout.

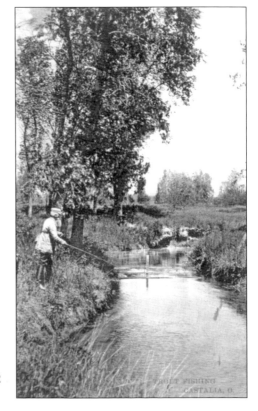

This 1908 postmarked card shows a member with his dog standing watch behind him. He is casting into a bend in the stream near one of the riffle dams. Members were also allowed to hunt on the premises during legal game seasons. In 1922, some 62 stone riffles with spawning beds, plus 15 riffle dams, were constructed. Considerable dredging has been done since 1922 to enlarge and add to the stream's length.

The Castalia Trout Club maintains strictly "purist" fishing with artificial flies—either dry or wet. Many members tie their own special flies. The wary trout know more about the flies than the man fishing. Large fish have been caught with a row of as many as six rusty hooks around the end of their mouths. Record fish caught at the club include a 13.5-pound brown, a 10.5-pound rainbow, a 3.5-pound brook, and a 4.25-pound tiger.

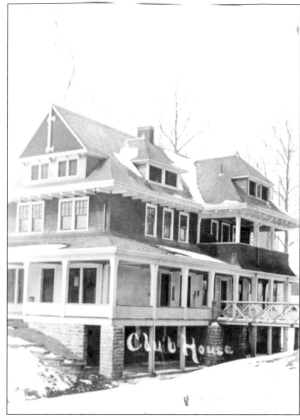

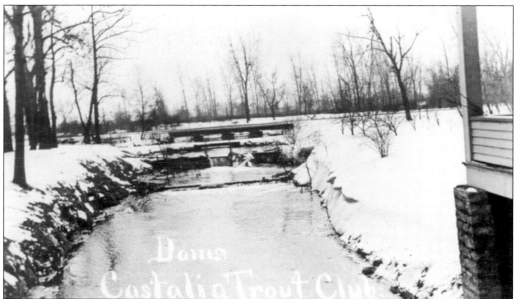

This postcard view looks south from the corner of the clubhouse across the dams in Cold Creek and the railroad trestle bridges. Farther east, to the left, along the railroad tracks is a smaller spring supplying some water to the fish hatchery building. This spring is about 175 feet in diameter and 10 feet deep.

This is a photograph of Floyd Stewart (1924–1988), who was the manager of the Castalia Trout Club from 1969 to 1987. Floyd's wife, Wanda, was manager of the club's dining hall and the log cabin operation at the Blue Hole during the same time period. Current managers are Barry and Sherri Brunner. Earlier managers were Webb Sadler (1930–1945) and Everett Reeves (1945–1969).

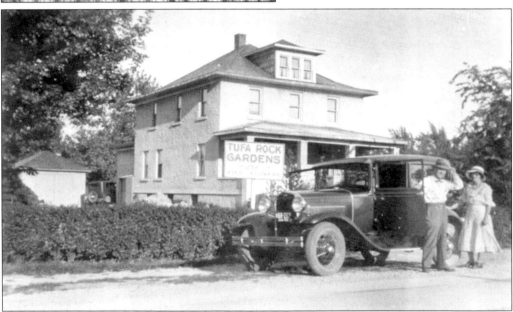

Just north of the Blue Hole entrance on Route 269 is the small community locally known as Skunktown. The nearest home was Tufa Rock Gardens, owned by Charles Eggert (1861–1951). Tufa rock, also called travertine, is porous, spongy-looking rock formed by carbonate of lime solidifying on vegetation. Tufa is irregularly deposited in over 4,000 acres west and northwest of Castalia in various shaped masses ranging in thickness from several inches to four feet.

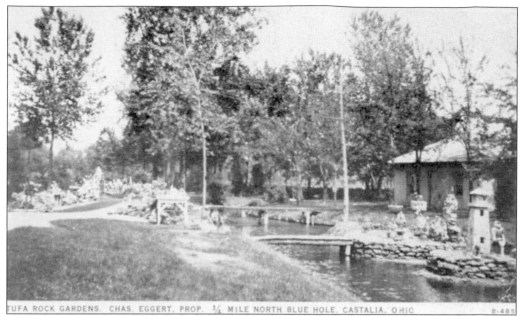

TUFA ROCK GARDENS. CHAS. EGGERT. PROP. ¼ MILE NORTH BLUE HOLE. CASTALIA. OHIO B-485

Water from Cold Creek was channeled around this roadside property to form an island, as shown in this postcard. The channel was filled in during the early 1960s. Eggert sculpted many different decorative items, which still adorn area home gardens/yards. Many tons of tufa rocks were sold for decorating and building projects all over the country. Julian Miller was also a Castalia dealer in tufa rock back in 1928.

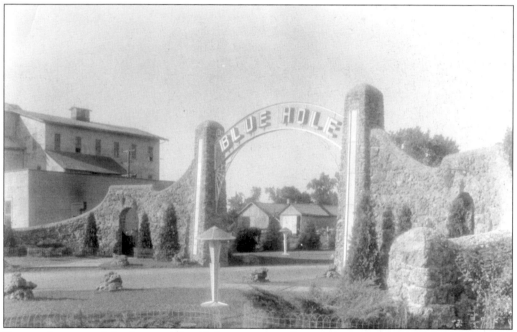

Eggert also created the famous Blue Hole entrance arch out of native tufa rock in 1935. Clumps of tufa rock decorate the sides of the entrance road along with the mushroom-looking pedestal lamps. The buildings to the left in this photograph comprised the Castalia Elevator, most having been removed. Cloud's Antique Mall currently occupies this site.

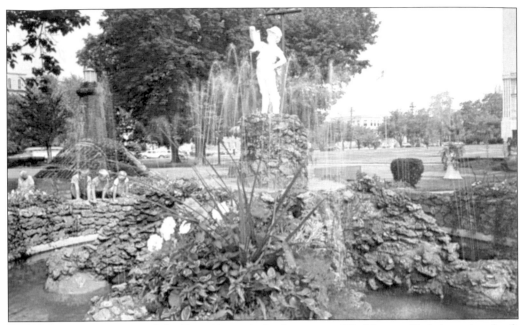

Sandusky's famous Boy and the Boot Fountain in downtown Washington Park is made of tufa rock. This fountain has stood in front of the Erie County courthouse since the 1930s. The original boy statue (currently in the Follett House Museum) was brought to Sandusky in 1895 by Voltaire Scott.

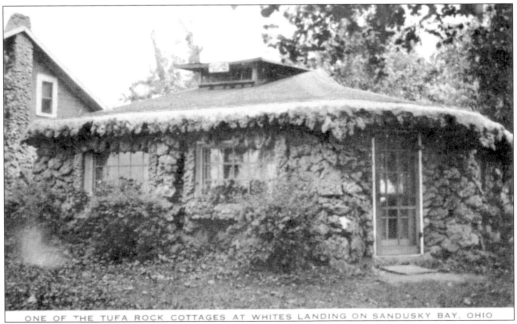

ONE OF THE TUFA ROCK COTTAGES AT WHITES LANDING ON SANDUSKY BAY, OHIO

Numerous cottages were also constructed out of tufa rock. They were located in the village of Whites Landing on Sandusky Bay to the west of Venice. A 1941 Lake Erie tourist guide notes "the picturesque cottages are cool and well insulated inside." Many of these small homes are still occupied. The tufa rock cottage walls and chimneys are quite decorative.

The area northwest of Castalia is currently the Resthaven Wildlife Area, encompassing 2,210 acres. The Ohio Wildlife Division purchased this land in 1942 as a public recreation area for hunting and fishing. This flat prairie land was originally strip-mined for marl and yellow clay, which were used in the manufacture of cement. These calcium carbonate–containing materials, plus gypsum, were transported to the mills via dinky trains, as illustrated in this recent painting by Robert Lorenz of Fremont.

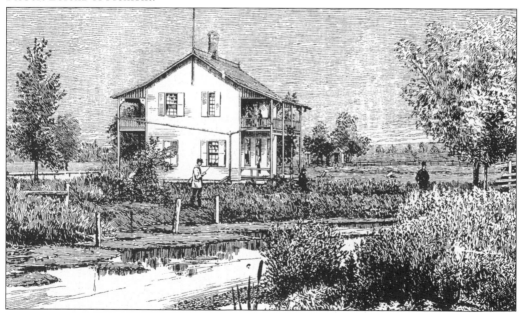

In 1878, John Heywood, grandson of Russell Heywood, leased the rights of Cold Creek, from the Castalia Trout Club's northern boundary to Sandusky Bay, to the Union Club of Cleveland. This "Lower Club" became the Castalia Sporting Club in 1881, initially with 25 members. They built a small clubhouse and fish hatchery at the intersection of Heywood and Homegardner Roads. This illustration is from the May 1891 issue of *Forest and Stream*.

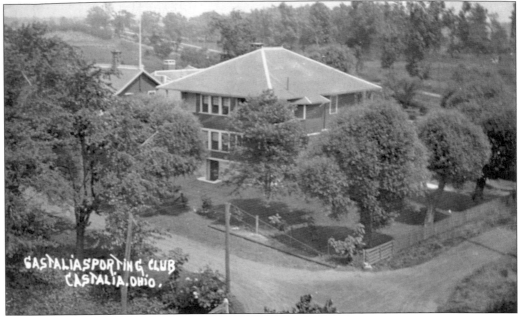

A larger clubhouse and lodge was built in the late 1890s to the south of the original building, the rooftop being visible in this 1910 Ernst Niebergall postcard. Heywood Road is in the foreground with Homegardner Road on the right where the bridge crosses the Race. The 1896 atlas shows that John Miller and his son August G. Miller owned the property surrounding the club that earlier was Heywood's Subdivision.

August G. Miller (1847–1906), born in North Prussia, Germany, was the keeper of the Castalia Sporting Club House grounds and stream starting in 1878. He accidentally died, falling in the hatchery building. Miller was a prominent farmer and an avid trout fisherman. According to *Forest and Stream* of May 1891, he was "the first man to protect the trout of the Castalia stream." It was the club's purchase of the stream property that enabled it to permanently stamp out fish poaching.

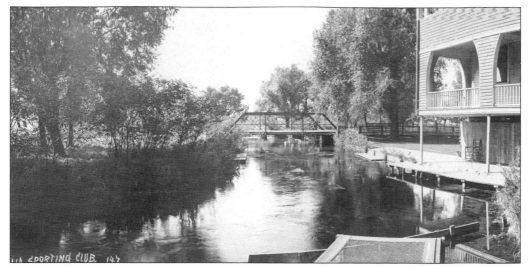

This early Niebergall panoramic photograph shows the first iron truss bridge where Homegardner Road crosses over the Race. This bridge was replaced in 1967 with a prestressed concrete beam bridge. This is currently a very popular spot to view and feed the hungry, churning mass of trout that gathers under the bridge. The Castalia Sporting Club House, on the right, was torn down in 1937 due to soil erosion around the foundation. (Hayes Presidential Center.)

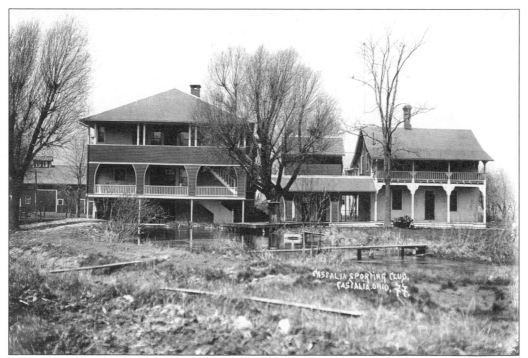

Cold Creek flows fast enough that it supposedly never freezes in the winter months. However, in February 1885, Miller reported to the *Sandusky Register* newspaper that with the temperature at minus 12–18 degrees, the Race was frozen for 36 hours, thick enough to hold a man's weight. In January 1893, the trout stream again froze with nine-inch-thick ice. The trout were unharmed. This photograph was taken before 1937. (Hayes Presidential Center.)

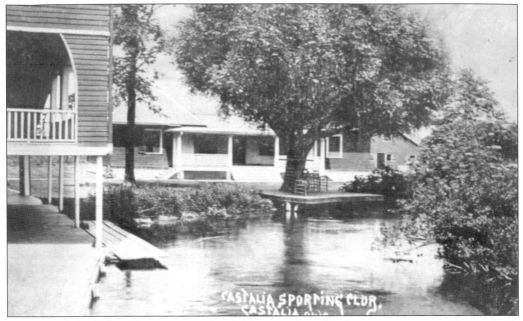

In 1891, while drilling for water on the club's grounds, a flowing stream was struck at a depth of 60 feet producing a forceful gusher four feet high. In 1893, the ground caved in to form another "blue hole" spring about 60 feet in diameter. The club has on display an old elm tree root dug up in 1979 from a depth of seven feet on the club property. It dates from 90 BC per carbon-14 testing.

In early 1936, the assets of the Castalia Sporting Club were sold to the Castalia Company, headed by William Levis of Toledo. Levis, in this photograph, was the president of the Owens-Illinois Glass Company. Julian Miller continued as the superintendent. By 1937, Castalia Farms was a 1,000-acre private estate with 10 miles of winding trout stream north to Venice, plus four miles of nursery stream. The stream is nominally 20 feet wide with an average depth of 5 feet.

This view of the Castalia Farms Club House, as viewed from the Homegardner Road bridge, was painted in 1978 by Elmer Grahl, a Sandusky barber. This color painting was used on wine bottle labels by Steuk's Winery in Sandusky and Venice. In 1959, Castalia Farms was purchased by John and Daniel Galbreath of Columbus. Walter Gysan continued as farm manager. Since 1965, Castalia Farms has been owned and maintained as a management center by Owens-Illinois.

STEUK'S

Barrel-Fermented American Chardonnay
sur lies
produced and bottled by
steuk wine company, sandusky, ohio 44870
alcohol 11% by volume contains sulfiting agents

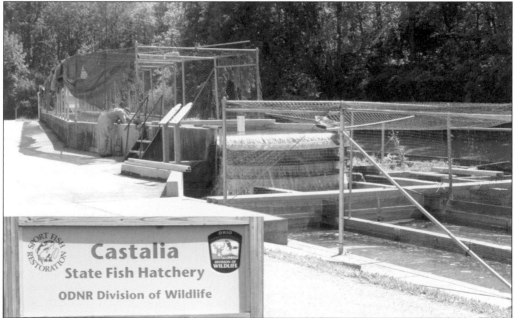

Castalia
State Fish Hatchery
ODNR Division of Wildlife

The Castalia Farms trout hatchery and spring were privately purchased in 1992. In 1997, the Ohio Division of Wildlife purchased the 90-acre Castalia Trout Farms. The state hatchery now raises annually over 500,000 steelhead and rainbow trout. The Hatchery Blue Hole spring is about 22 feet deep and is fed by the same underground aquifier that feeds the other Cold Creek springs. Permit fishing is allowed on a lottery basis.

This 1910 dated postcard (No. 82) by Ernst Niebergall identifies the "scene as near Castalia." The stream is assumed to be Cold Creek. Note the several footbridges crossing the stream. Below is an illustration of Russell Hubbard Heywood (1797–1883), who was born in Worcester, Massachusetts. He moved to Buffalo, New York, in 1824 where he operated a small general store. In 1844, he founded the Buffalo Board of Trade.

In June 1831, Heywood moved to Margaretta Township and purchased 500 acres of land, Cold Creek water rights, and the Venice flour mill for $10,000. In July 1831, he and John Camp purchased 13,000 acres for $1 per acre. "Mr. Heywood was the whole of the village of Venice," was recorded in the Buffalo Historical Society publications. In 1874, Heywood still owned 3,100 acres. He died in his Sandusky home and was buried in Buffalo. (Buffalo and Erie County Historical Society.)

Five

HEYWOOD FLOUR MILLS

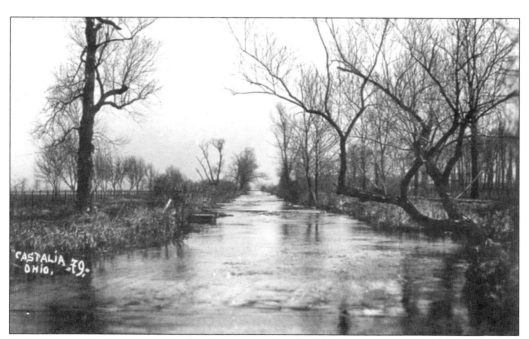

This view of the Race looks southwest toward the Castalia Farms property. On the left side is the fence line along Homegardner Road. In 1816, Maj. Frederick Falley and Eli Hunt signed an agreement covering the right to carry a canal from Castalia to Venice. In 1817, excavation began on the millrace portion from the Sunnybrook Pond site on Route 6 (west of Venice) to the Venice flour mill, which was built in 1824.

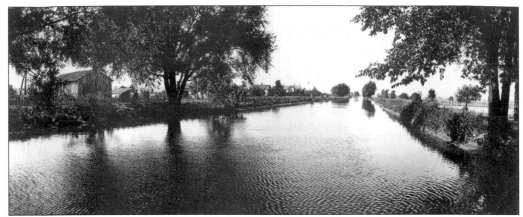

This Ernst Niebergall panoramic photograph of the Race also looks southwest showing numerous farm buildings along Homegardner Road. An 1831 Margaretta Township map depicts existing "canals." However, historians cite 1838 as when Russell Heywood had the above two miles of canal dug at a cost of $60,000. By the early 1900s, this land had been divided into many farms capitalizing on the rich soil. The 1874 atlas cites, "Cold Creek runs in an artificial canal its entire length." (Hayes Presidential Center.)

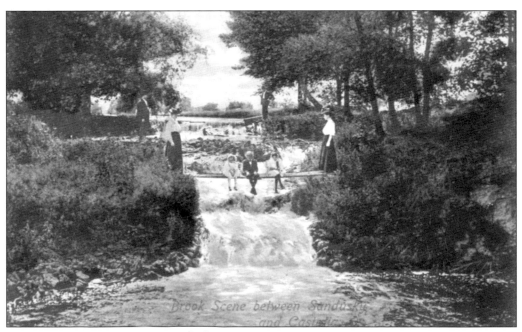

This "Brook Scene between Sandusky and Castalia" must certainly be the significant falls of the Race at Heywood's brick flour mill site on Homegardner Road. The Race was dammed up at the mill to provide a 21-foot head of water to power the mill machinery. The mill was destroyed by fire in 1888, after which the dam was removed, leaving scenic waterfalls. The falls have now eroded away over 70 feet from the original mill site.

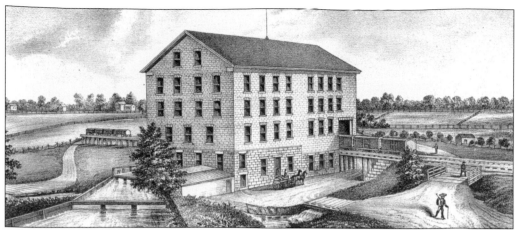

Russell Heywood built this flour mill in 1839–1841 at a cost of $50,000, with eight runs of stone, on Homegardner Road just west of Bardshar Road. This artist illustration is from the 1874 Erie County atlas. This wooden structure mill was destroyed by fire in 1848, and was rebuilt in 1852 out of bricks and stone, becoming known as the "Brick Mill." The Race is depicted in the foreground flowing into the mill.

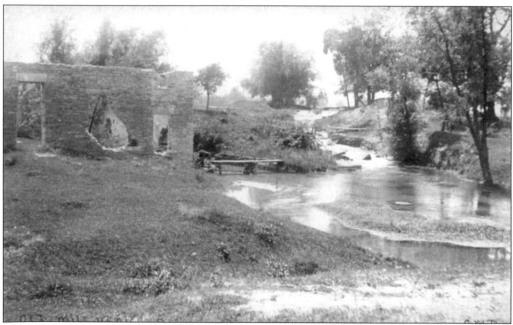

In 1871, the five-story flour mill was 55 feet wide by 109 feet long and 59 feet high. It contained six runs of burr stone, four and one half foot in diameter, with a daily capacity of 250 barrels. This mill was still operating in 1879 according to recorded history. Heywood died in 1883. The mill was destroyed by fire in 1888, but the stone walls remained, as shown in this old photograph. (Dave Berckmueller collection.)

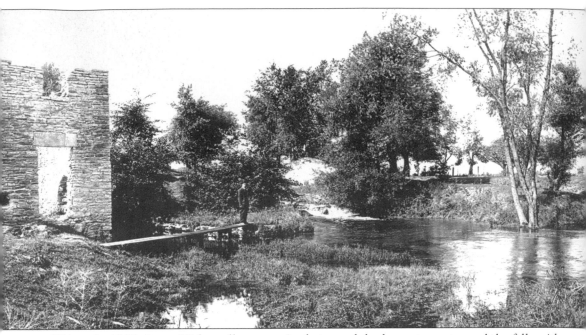

This early-1900s Ernst Niebergall panoramic photograph looks upstream toward the falls with the Race flowing north under a bridge, which crosses over to some farm buildings. In the 1896 Erie County atlas, this farm property, west side of the Race, was owned by William Herr, while the east side property was owned by W. G. Neuchler. It is unknown when this bridge was removed. In the late 1940s, when J. Preston Levis owned this old millsite property, the farm

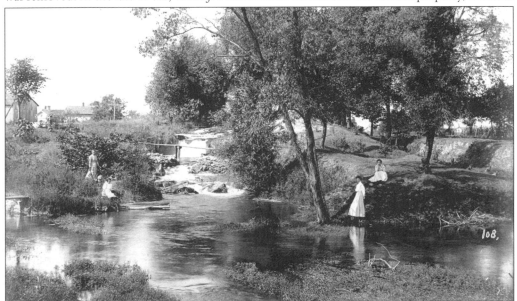

This early-1900s photograph shows how much the Race falls have receded back from the mill location. Power to mill machinery was provided by two 18-foot overshot waterwheels. In 1871, premium Heywood Mills XXXX white wheat flour was selling for $9.50 per barrel. Farmers hauled their wheat to the mill via horse and wagons. After 1852, a spur of the Mad River and Lake Erie Railroad crossed Homegardner Road into the mill. (Hayes Presidential Center.)

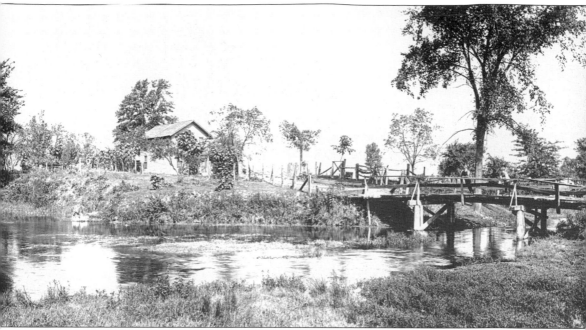

buildings were replaced with a house for Julian Miller, Millsite Farm manager, that also served as the kitchen and dining hall for the Levis estate. This site is now privately owned. In 1871, it was reported that over 40,000 bushels were hauled by wagons to the Castalia-area flour mills. (Hayes Presidential Center.)

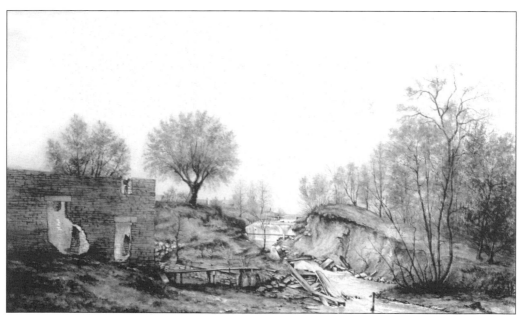

Ralph Smalley Tebbutt (1849–1930), a well-known Sandusky artist, painted this scene of the Heywood mill ruins and the falls. Tebbutt was born in England and came to Sandusky in 1854. He was in business with another local artist, John Holland, until 1895. He was engaged in the painting and decorating business for 60 years. (From the collection of the Sandusky Library Follett House Museum.)

Elmer Grahl, a Sandusky barber, painted this winter scene of the Heywood mill ruins in 1995. John A. Miller, a Bardshar Road farmer, recalls his grandfather August F. Miller (1847–1924) telling how he worked in the mill and Russell Heywood paid him $1 or one acre of land per day. When August had accumulated 60 acres, he quit the mill and went into farming. (John Miller collection.)

This c. 1910 real-photo postcard by Adolph R. Rheinegger shows the falls of the Race near the Heywood flour mill site. Perhaps the barrel in the foreground is an old flour barrel found in the ruins of the mill. Rheinegger (1871–1943) was a Sandusky barber, although he was listed as a photographer in the 1910 Sandusky directory. Numerous old Cedar Point postcards bear his name.

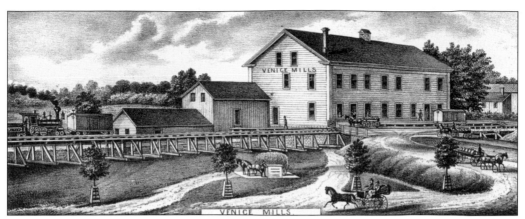

Russell Heywood also operated a second flour mill in Venice powered by the one-mile-long tailrace from the Homegardner Road mill location, as shown in this 1874 artist illustration. Heywood purchased this original mill site (first built in 1824), 500 acres of land, and the Cold Creek water rights in June 1831 for $10,000. Construction of his new flour mill began in January 1832.It was completed in June 1833, using hand-hewn timbers and wooden pegs.

The 1874 atlas map of Venice shows the location of the Heywood Mill between Cold Creek and Market Street, now U.S. Route 6. Heywood also built a 600-foot pier into Sandusky Bay to facilitate lake-sailing ships. An 1872 map shows railroad tracks going out onto the pier. With the spur track connecting the mill to the Lake Shore and Michigan Southern Railroad, rail shipping gradually replaced the use of ships. Any remnants of the pier are no longer visible.

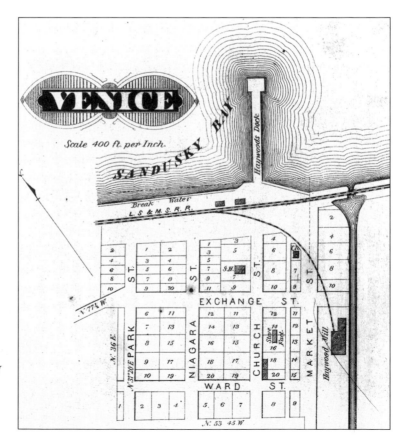

KILBOURNE MFG. CO., SANDUSKY, OHIO

Large quantities of flour barrels were made in Venice and Castalia to satisfy the needs of the mills. At one time these cooperages employed over 300 men. This postcard shows the Kilbourne cooperage that was destroyed in the 1924 tornado. Some other barrel factories in Sandusky were Schwab, Asher, and Michel. The 1874 map illustrates a stave factory opposite the mill. Area residents recall a Venice cooperage at the corner of Church and Ward Streets.

In 1911, an 87-year-old Margaretta Township pioneer recalled seeing as many as 25 heavy covered wagons loaded with wheat passing his home on their way to the Venice mill. Wheat was transported from over 100 miles in all directions where the wheat was grown. These wagon trains probably looked like these 1813 duPont powder wagons portrayed on this 1913 postcard. In 1871, it was reported that Erie County was one of the best wheat-growing regions in the United States.

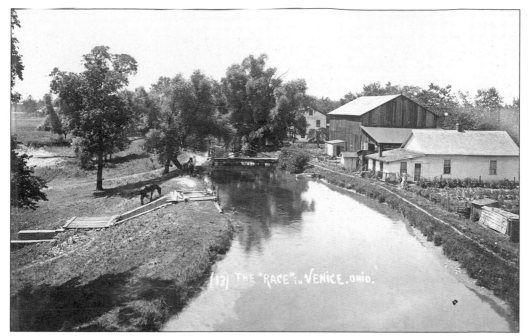

This view shows Cold Creek flowing east from Bardshar Road toward the mill. The navigable headrace, dam, pond, and tailrace cost about $10,000. In the early 1800s, grain was transported to the local mills via wagons pulled by oxen, coming from as far south as Columbus. Grain was brought from many counties by horses, railroads and lastly trucks. Heywood established the first permanent cash market for wheat in the Firelands. (Hayes Presidential Center.)

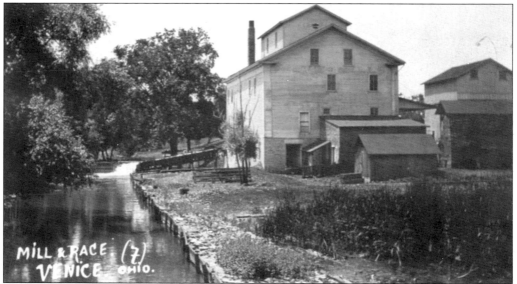

The Venice mill was rebuilt in 1861. As reported in 1871, the flour mill structure was three stories plus an attic and was 40 feet wide by 84 feet long in size. The first story was stone, and the other stories were frame construction, with an attached 24-foot-wide-by-70-foot-long warehouse. The mill utilized four runs of 4.5-foot-diameter burr stones, giving an annual capacity of 75,000 barrels. In 1858, mill superintendent H. N. Fish reported shipments of 81,261 barrels.

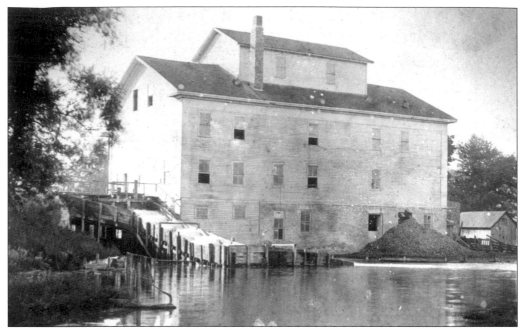

Power to the mill was generated by a 10-foot-diameter overshot waterwheel fed by a 12-foot head of water. Cold Creek water is flowing down the flume on the west end of the building. The first flour shipment east from Ohio went from Venice to New York in 1834. These 100 barrels, painted in China vermillion, were shipped by sailboat to Buffalo and then by canal boat to New York. Hundreds of people turned out to witness their arrival.

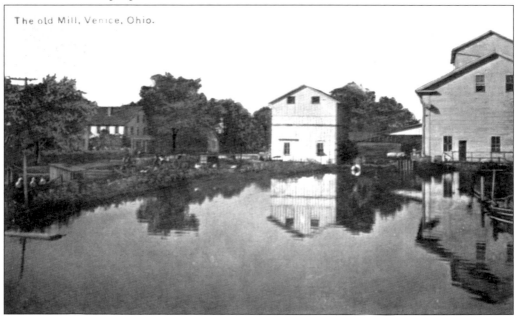

The old Mill, Venice, Ohio.

This view shows the headrace pond on the west side of the mill. Stores opposite the mill property are visible. In 1875, capacity was expanded to 125 barrels of flour every 24 hours of operation. In 1879, John Heywood, grandson of Russell, and T. L. Williams installed new machinery throughout the mill. Steel rollers replaced the grinding stones to produce very superior flour.

This *c.* 1890 trade card advertises Flourine, a pure unadulterated family flour manufactured by Heywood and Williams of Sandusky. The reverse side states, "Ladies will find that Flourine will make nicer bread, cake, biscuit and rolls than any other flour in the market. By its own intrinsic merit it has forced its way into popularity, and all who use it speak loudly in its praise." Exclusive wholesale dealers were W. and C. R. Milliken.

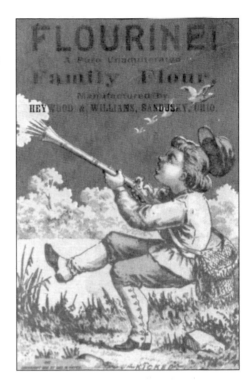

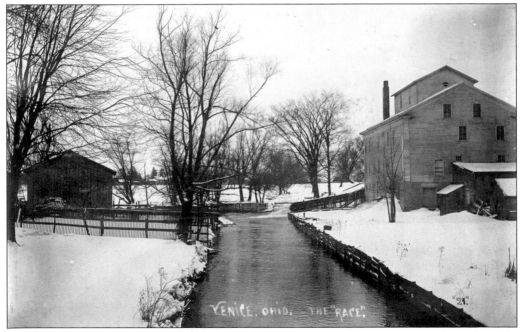

This winter view of the tailrace looks west back toward the mill from the road bridge. In 1897, the Gallagher brothers—John, Arthur, and James—purchased the mill property. They replaced the waterwheels with a water turbine having six-foot blades. A dam, with bottom gates, provided 13 feet of water pressure, yielding 150 horsepower to power the system of pulleys and conveyors. The building was increased to five stories with rectangular storage silos. (Hayes Presidential Center.)

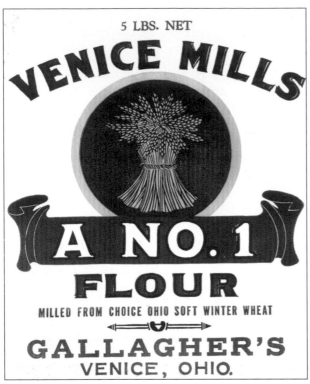

Gallagher's Venice Mill was the home of Little Wonder Flour. This 1940s paper bag advertises their winter wheat brand flour. In 1902, their Sandusky elevator and warehouse were located at the foot of Columbus Avenue. They sold flour, feed, seeds, hay, straw, salt, lime, cement, drain tile, coal, and grains. The feed store moved to Market Street years later and continues operations today. Mill operations ceased in May 1945, and the mill was totally closed by late 1946.

The wooden portion of the Venice mill was removed in 1962. The remaining stone structure has since been remodeled into a popular tavern and restaurant called Margaritaville. This recent photograph looks across the Old Venice Mill Pond to the restaurant dining room. Cold Creek is cascading down past the picture windows at a rate of over 10,000 gallons per minute, which equates to five billion gallons per year. Situated above the falls is the outdoor pavilion and cocktail lounge.

Six

ENTERPRISES ALONG THE RACE

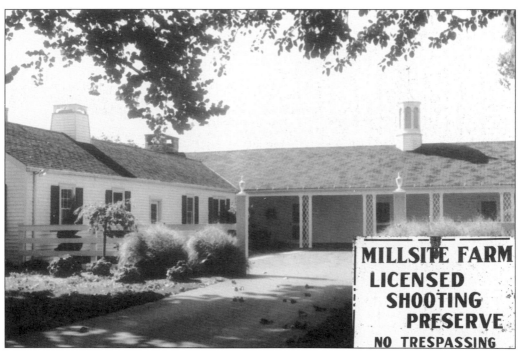

Millsite Farm was formerly owned by John Preston Levis (1901–1973), former board chairman of the Owens-Illinois Glass Company of Toledo, and encompassed the old Heywood brick mill property and sections of the Race. Former farm buildings bordering the north side of the Race on Heywood Road were converted into a luxurious fishing and hunting lodge for guests, as shown in this recent photograph. The property is now owned by O-I's Castalia Farms Operation.

The Millsite Farm crew dresses pheasants for guests after a day of hunting in late 1969. From left to right are farm manager Kenyon Miller, Mike Neill, Eugene Meyers, William Kuebeler, and Harold Morris. Millsite Farm was state licensed for small-game hunting. Ring-necked pheasants, partridge, and quail were purchased and kept in pens on the former Kuebeler Farm before being released for the hunters.

The one-room Brick Mill School was across Homegardner Road from the Heywood mill, on the west side of Bardshar Road. When centralization went into effect in early 1923, 11 Margaretta Township schoolhouses were abandoned and sold at auction in late 1923. Arthur Gallagher, a Venice mill owner, purchased the Brick Mill School building, which was demolished some years later.

The Heywood Road iron truss bridge spanning the tailrace is shown in this 1951 photograph. This bridge was replaced in 1955 with a camel-back, steel truss and floor, and again replaced in 2006. From the brick mill, the mile-long tailrace flows north to U.S. Route 6 before turning east to Venice. Flour was towed on scow-built canal boats to the Venice mill for transshipment. The boats had a capacity of 80 barrels.

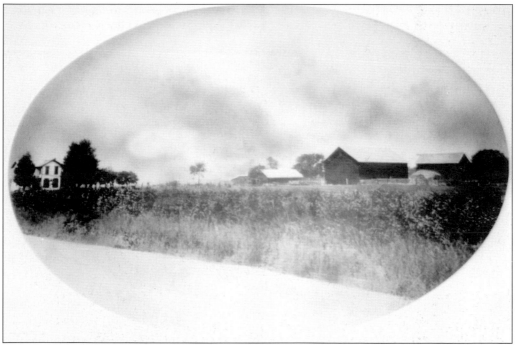

The Karl W. Kuebeler (1836–1933) farm on Heywood Road bordering the Race northward was typical of the Castalia area farms. This early-1900s photograph taken from the bridge shows Heywood Road as unpaved. Millsite Farm purchased this property in 1950. It is currently owned by the Sunnybrook Trout Club. The farmhouse on the left has been totally renovated. Only the large barn and cookhouse, used during hog butchering, still exist.

The towpath along the east side of the tailrace was timbered whenever necessary, as reported in 1871. This towpath was used by teams of horses towing the canal boats downstream to the Venice mill. The ends of numerous large logs can still be seen just below the water surface along this eastern bank of the Race. Logs are outlined for clarity in this 2006 photograph.

This 1951 photograph shows the weir in the Race preventing the Millsite Farm's trout from swimming on down to Venice. The fast-flowing water carries large amounts of vegetation, which continually clog the vertical openings in the weir. This required daily cleaning. The Race curves east into the Zimmerman property, now Sunnybrook. To the left is marshland.

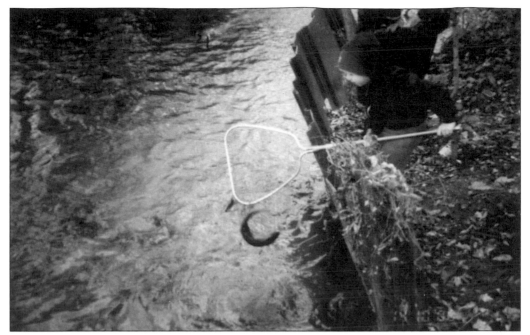

The section of Cold Creek (the Race) northeast from the Sunnybrook Trout Club property to Venice is now privately owned by Ronald Scheufler. In this 2006 photograph, his grandson Ramiz Nseir has netted a two-to-three-pound rainbow trout. Cold Creek flows under the Bardshar Road bridge to the old flour mill location, now Margaritaville.

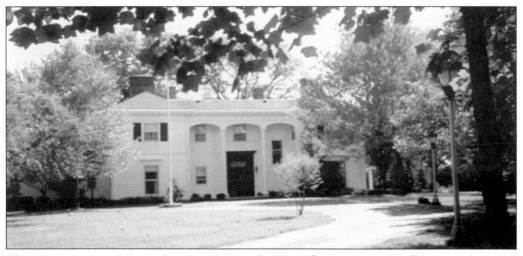

The 1831 Margaretta Township map depicts the Race flowing into a small lake on the south side of Route 6. Starting in 1817, a canal was excavated from this lake to conduct Cold Creek water to Venice. A sawmill operated at this location in 1819. Herbert Farrell Jr., from Sandusky, purchased this property in 1941 and built the house shown in this 1980s photograph. Rowland Zimmerman purchased the Sunnybrook estate in 1943.

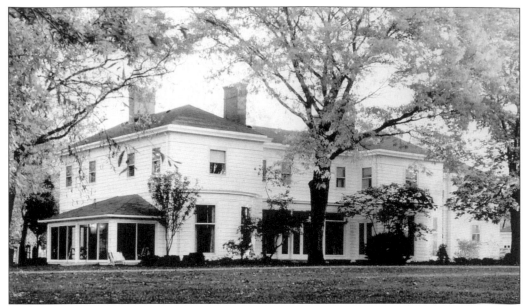

In 1999, the Sunnybrook estate was purchased by Doug Lamb, who now operates it as the Sunnybrook Conference Center and Trout Club. The 7,000-square-foot Southern-style mansion contains 26 rooms. In 2001, Lamb purchased the former 90-acre Kuebeler and Tymkewicz farm on Heywood Road. The current 130-acre landscaped woodlands feature over two miles of Cold Creek teeming with trout.

William Levis originally purchased this stream property in 1937 and then sold the 40-acre site to Farrell. Walter Gysan bought the property in 1963 and sold it to Owens-Illinois in 1968. It was again sold in 1987 to John Kern, who then started Sunnybrook Trout Club. This eight-pound trophy rainbow trout displays the Sunnybrook fly-fishing challenge. An 11-plus-pound trophy brown trout, 25 inches long, is displayed in the club dining hall.

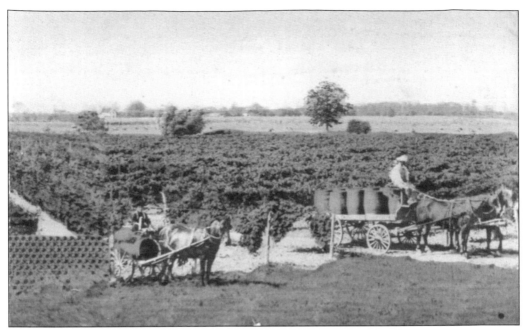

In 1871, the Sandusky newspaper reported the Venice area to be the "finest fruit and vine region in the vicinity with the land for grapes equaling that of Kelleys Island." In 1867, there were over 300 acres of vineyards near Venice with William Mills of Sandusky having the largest of 80 acres. In 1868, it was reported that production from the Sandusky and Lake Erie Islands region were two million pounds of grapes and 400,000 gallons of wine.

John G. Dorn (1861–1934) operated a Sandusky winery in a native limestone building originally erected in 1837. The House of Dorn was founded by his father in 1869. Dorn maintained over 70 acres of vineyard in Venice, on the south side of Cold Creek and west of Bardshar Road. Cut-price California mass production competition forced the winery to close in 1956. The Dorn family donated the Venice property to the City of Sandusky for use as a community park.

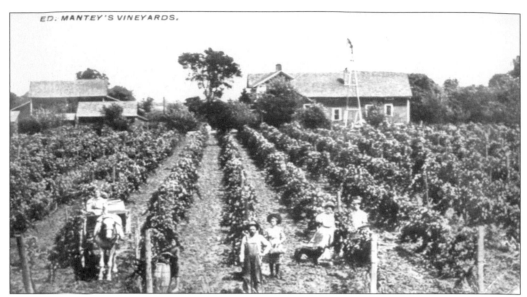

ED. MANTEY'S VINEYARDS.

Edward Mantey founded his winery in 1880 with vineyards extending from Bardshar Road west to Cold Creek. Capacity in 1938 was 25,000 gallons with cellar storage in large oak casks. Production that year was 15,000 gallons using all locally grown grapes. During Prohibition, the winery survived on sales of unfermented grape juice. In 1979, Mantey's was the second-largest winery (out of the 34) in Ohio. Mantey's wines have won numerous national award medals.

FIRELANDS

In 1981, Paramount Distillers purchased Mantey's winery, which then became Firelands Winery. The original wine cellar and Mantey family home have been integrated into the present winery shown in this 2006 photograph. Firelands currently has extensive vineyards on Isle St. George (North Bass Island) in Lake Erie, which provide unique grape-growing conditions. This northern area of Cold Creek and the southern shore of Lake Erie are renowned for their rich viticultural history.

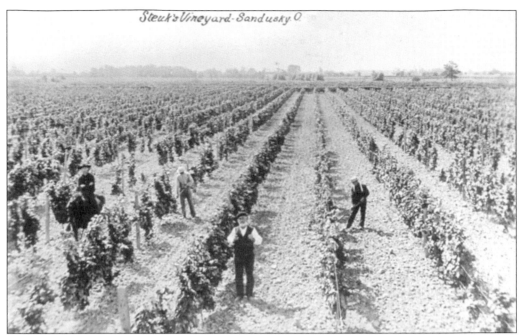

In 1865, William L. Steuk commenced a small winery in a Sandusky cellar. Louis Harms, his partner until 1876, was one of the pioneer grape growers on Put-in-Bay (South Bass Island). Steuk purchased land on Venice Road, west of Sandusky, which became an important grape-vine nursery. Steuk died in 1876 and his son, Edward, took over the family business. The winery was enlarged, and the vineyards in Venice were acquired.

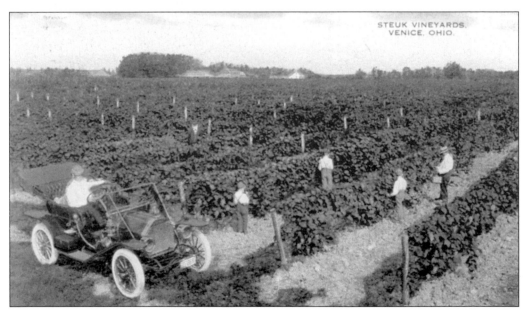

When Edward Steuk died in 1917, his son William Louis continued the family business. The winery produced dry-variety wines, semisweet wines, and champagne. However, it was William's lot to have to comply with the newly enacted Prohibition law in 1919 and close the winery. The Venice vineyards (to the north of Cold Creek) were continued along with expanded fruit orchards.

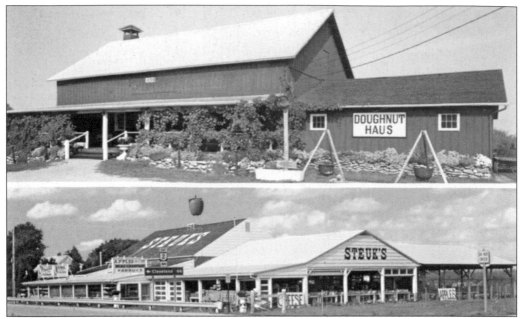

After the repeal of Prohibition in 1933, William returned to wine making. Edward's grandson William Karl became the owner and operator of the Steuk family business, bringing in modern viticulture technology. Steuk's roadside fruit market and winery was a well-known stop on U.S. Route 6 west of Venice for many years. The facility closed in late 1997.

Yellow clay was dug in the 1940s through the 1950s from these lagoons near Bay Bridge for the manufacture of cement. Lagoon Deer Park is located nearby on State Route 269 north of U.S. Route 6 and features over 200 freely roaming animals of many species, eager to be hand-fed by the visitors. The park's four lagoons are now stocked for paid public fishing with rainbow trout, walleyed pike, largemouth bass, channel catfish, and perch.

Seven varieties of imported foreign deer inhabit the park and roam about among the visitors looking for food handouts. Deer Park was started in 1956 by the Nielsen family, which continues to operate the facility. The park's 12-to-18-foot-deep lagoons are fed by the existing water table and were dug by steam shovels. The dinky trains traveled past the lagoons to transport the yellow clay to the Bay Bridge cement mill.

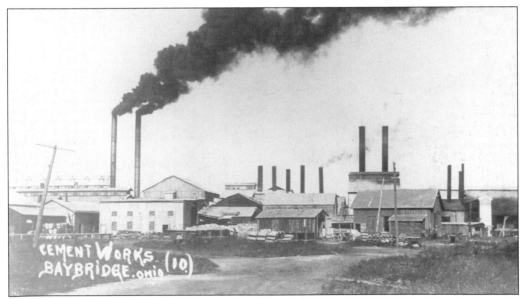

The Sandusky Portland Cement Company was founded by Dr. John Newberry's three sons, who built this plant in 1892 at Bay Bridge. Dr. Newberry had conducted geological surveys of Ohio in the 1860s and the 1870s when rich deposits of marl and clay were discovered near Sandusky Bay. These were estimated to be capable of producing 4.5 million barrels of cement. In 1927, the name was changed to the Medusa Portland Cement Company after the Medusa trademark.

Form 35A-2M 7/28/11

Sandusky Portland Cement Co.

GENERAL OFFICE

SANDUSKY, OHIO, OCT 1 0 1912

Gentlemen: Please return to us at your earliest convenience, by freight, **PREPAID,** *the empty duck sacks of our brand now in your hands, as we are greatly in need of them. Please bill same to our works at* **BAY BRIDGE, ERIE CO., OHIO,** *and mail Bill of Lading to this office.*

Yours truly,

Sandusky Portland Cement Co.

Per

Important

This 1912 postcard displays the Medusa trademark prior to the company name change. The postal cancellation on the reverse side commemorates the upcoming 1913 Perry's Victory Centennial at Put-in-Bay. A historical marker was erected near the plant site in 2005 by the Erie County Historical Society.

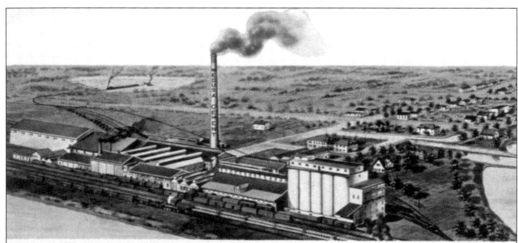

We advise shipment today from our Bay Bridge, Ohio Mill as follows:-

THE SANDUSKY CEMENT COMPANY.

The Medusa Plant's annual capacity in 1938 was nine million barrels of cement. The dinky trains were daily bringing in over 200 carloads of raw materials. These materials were crushed, ground, mixed with water, passed through a 2,600-degree kiln, and reground to produce Portland cement. Manufacturing operations ended in late 1960 due to the diminished local supply of marl. The huge cement storage silos still grace the Sandusky Bay skyline.

Seven

VENICE

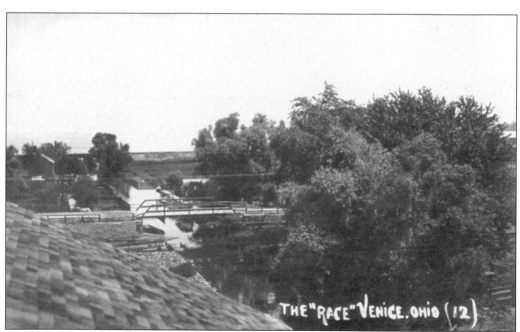

This Ernst Niebergall photograph postcard, postmarked 1909, was taken from the roof of the Venice flour mill looking east to Sandusky Bay. Cold Creek, or the Race, flows under the wagon road, now U.S. Route 6, bridge and then under the railroad bridge. Canal boats transported barrels of flour to the ships waiting along the Heywood pier. The iron truss structure of the road bridge is clearly visible.

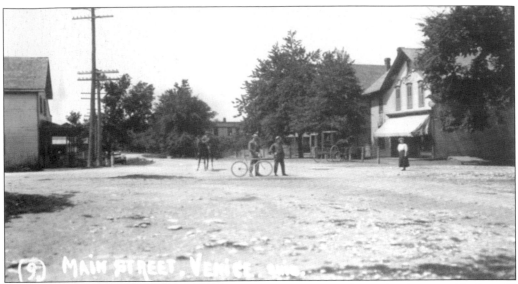

This early view of Venice looks west along Main Street, formerly Market Street, with the mill buildings on the left side. This building may have been the office/store for the mill. The village was established in 1816–1817 by Maj. Frederick Falley, and lots were sold. The 1831 Margaretta Township map identifies the village as Jessupville. Ebenezer Jessup became sole proprietor of the township about 1827. Venice became a very prosperous community. Venice was annexed into Sandusky in 1962.

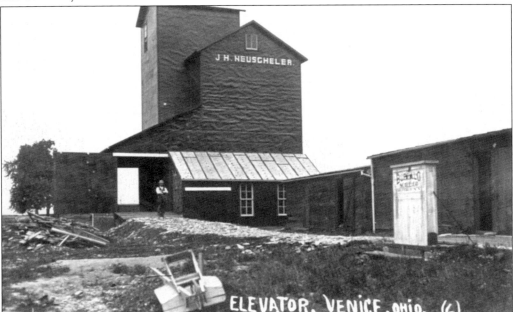

John Neuscheler (1860–1949) operated an elevator along the railroad tracks near the mouth of Cold Creek. From the late 1890s, John sold agricultural implements, wagons, buggies, bicycles, coal, drain tile, grain, seeds, salt, animal feeds, and flour. In August 1971, the vacant building was destroyed in a controlled burning by the Sandusky Fire Department. Jane Neuscheler, John's daughter, operated the Venice Post Office in a small building in front of the elevator from 1932 until it closed in the 1960s.

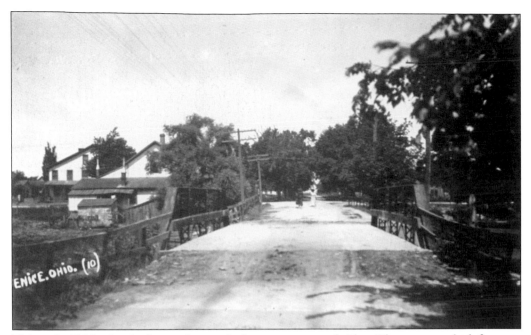

This early-1900s view looks north over the iron-truss wagon bridge. The stores on the left are on the northwest corner of Exchange and Market Streets. G. Smith operated a store selling general merchandise. Russell Heywood erected the small, stone Church of Our Redeemer in 1866 as a memorial to his departed family members. The church cost $12,000 and was located near Cold Creek on the east side of Bardshar Road.

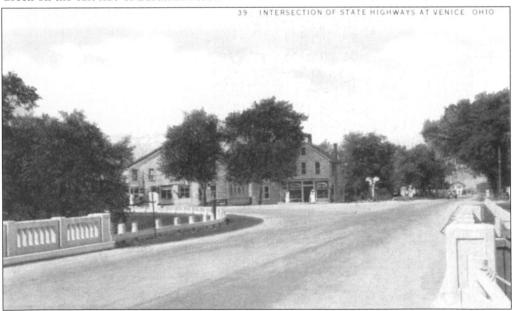

This 1930s postcard by E. B. Ackley of Sandusky shows the Route 6 bridge, over Cold Creek, after having been rebuilt. This view is looking north with Route 6 curving left and the stores straight ahead. Old Route 2 went north to Bay Bridge. Anna Sessler's corner tavern was managed by Frank Trautlein in 1903. This was Nottke's Tavern in later years before being torn down. Grahl's barbershop was across the road to the right.

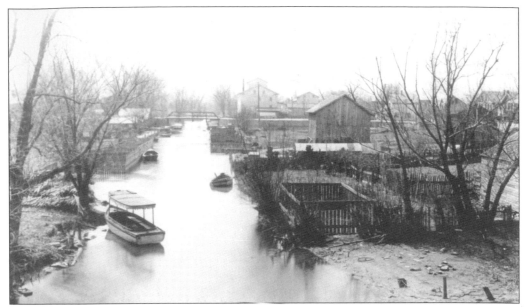

This Ernst Niebergall postcard view, presumably taken from the railroad bridge, looks west back along Cold Creek to the flour mill in the distance. Slotted fish pens can be seen beyond the small boat. On the left side of Cold Creek was a boat landing for pleasure craft rides, both upstream past the mill and out into Sandusky Bay.

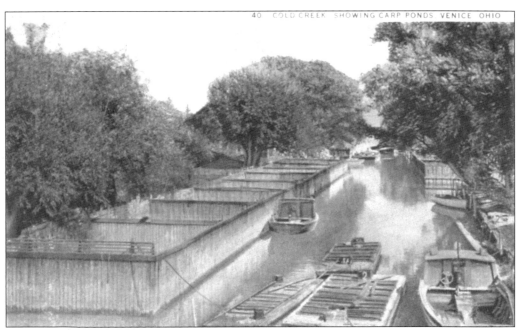

Large slotted, wooden pens in Cold Creek held carp, netted out in Sandusky Bay, until shipped live to the fish markets in New York City and other eastern locations. In 1949, Nielsen Brothers Fisheries had eight pens holding up to 60 tons of live fish for fattening up before shipment. Specially equipped New York Central Railroad cars had aerated tanks holding 30,000 pounds of fish. One million pounds were shipped in one season. These pens were still in use into the 1960s.

This 1896 advertising postcard from the Nielsen Brothers—Charles, Clarence, and Cyrus—notes a Sandusky office location. Carp, a native fish from China, were first brought to America about 1876 and multiplied rapidly. Commercial fishermen took carp from the Great Lakes for the first time in the 1880s and by 1950 were catching over five million pounds a year.

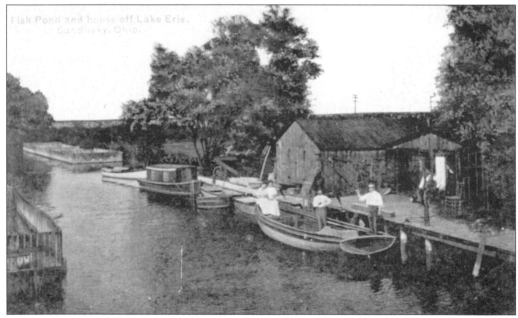

This early postcard of the Venice fish pond and house shows the boat landing on the south side of Cold Creek that was operated by the Martin family. An existing 1912 Niebergall photograph shows some 20 people boarding a canopied boat *Silver Star* for a pleasure ride on the Sandusky Bay. Fort Sandusky, erected in 1761 by the British, once stood just west of the mouth of Cold Creek. It was destroyed in 1763 during Pontiac's Conspiracy.

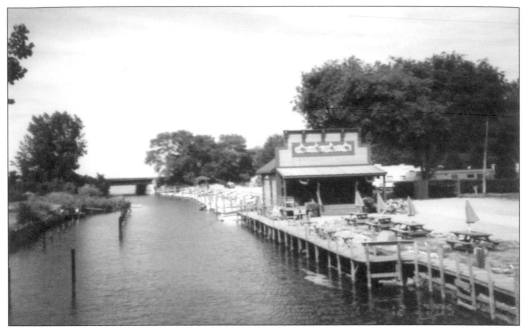

The Cold Creek Trout Camp now occupies the former boat landing site on the south side of Cold Creek, extending to the mouth into Sandusky Bay. This fish camp offers boat dockage and launching, camping and RV sites, and year-round fishing for a variety of fish such as trout, pike, and bass. Cold Creek remains at a 48-52 degrees Fahrenheit all year round and never freezes. Venice shorelines have disappeared over the past years due to rising Sandusky Bay water levels.

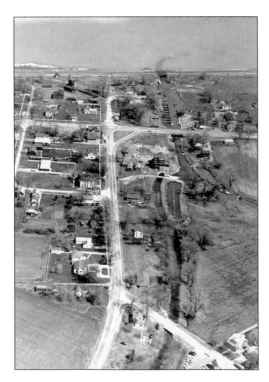

This 1958 Tom Root Air Photo image of Plymouth shows Cold Creek flowing northeast from Bardshar Road into the Sandusky Bay beneath the railroad bridge. Gallagher's flour mill is in a stage of demolition. Reclaimed heavy timbers were used in the Seneca Caverns building structure. The waterfalls at Margaritaville can be seen with the Race flowing into the millpond. Nielsen's carp pens and Neuscheler's elevator are also visible. (Hayes Presidential Center.)

BIBLIOGRAPHY

Aldrich, Lewis Cass. *History of Erie County Ohio*. Syracuse, New York: D. Mason and Company, 1889.

Arnold, H. Bartley. *The Castalia Trout Club Company*. Self-published, 1989.

Dickinson, Rev. S. C. *My Town*. Sandusky, Ohio: Stutz Printing Company, *c.* 1936.

Frohman, Charles E. *A History of Sandusky and Erie County*. Columbus, Ohio: Ohio Historical Society, 1965.

Frohman, Charles E. *Sandusky's Yesterdays*. Columbus, Ohio: Ohio Historical Society, 1968.

Hough, E. "The Castalia Stream." *Forest and Stream*, 1891.

Howe, Henry. *Historical Collections of Ohio*. Cincinnati, Ohio: C. J. Krehbiel and Company, 1900.

Kihn, Gary Edward. *A Thesis Entitled: Hydrogeology of the Bellevue-Castalia Area, North-Central Ohio, with an emphasis on Seneca Caverns*. Toledo, Ohio: University of Toledo, 1988.

Lawyer, Susan Benner. *Margaretta Township, Castalia Village Past and Present*. Castalia, Ohio: Cold Creek Girl Scouts, 1976.

Newell, Amy L. *The Caves of Put-in-Bay*. New Washington, Ohio: Herald Printing, 1995.

Peeke, Hewson L. *A Standard History of Erie County, Ohio*. Chicago, Illinois: Lewis Publishing Company, 1916.

Quick, Ellen Burggraf. *Quick's Castalia History*. Sandusky, Ohio: Commercial Printing Company, 1966.

Smith, Rev. H., and Harvey Fowler. "Incidents of the Early History of Margaretta." The *Firelands Pioneer*. Norwalk, Ohio: September 1860.

Stewart and Page. *Combination Atlas Map of Erie County Ohio*. Philadelphia, 1874.

Williams, W. W. *History of the Firelands, Comprising Huron and Erie Counties, Ohio*. Cleveland, Ohio: Press of Leader Printing Company, 1879.

ACROSS AMERICA, PEOPLE ARE DISCOVERING SOMETHING WONDERFUL. *THEIR HERITAGE.*

Arcadia Publishing is the leading local history publisher in the United States. With more than 3,000 titles in print and hundreds of new titles released every year, Arcadia has extensive specialized experience chronicling the history of communities and celebrating America's hidden stories, bringing to life the people, places, and events from the past. To discover the history of other communities across the nation, please visit:

www.arcadiapublishing.com

Customized search tools allow you to find regional history books about the town where you grew up, the cities where your friends and family live, the town where your parents met, or even that retirement spot you've been dreaming about.